IN A
SPIRITUAL STYLE

DEDICATION

For Maria McKenna, healer, friend, and model of courage and grace.
L.C.

IN A
SPIRITUAL STYLE

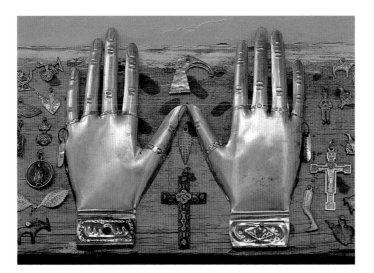

THE HOME AS
SANCTUARY

LAURA CERWINSKE
PHOTOGRAPHS BY MATTHEW FULLER

THAMES AND HUDSON

First published in hardcover in the United States of America in 1998 by Thames and Hudson Inc.,
500 Fifth Avenue, New York, New York, 10110

First published in Great Britain in 1998 by Thames and Hudson Ltd, London

Library of Congress Catalog Card Number 98-60337
ISBN 0–500–01873–1

British Library Cataloguing-in-Publication data
A catalog record for this book is available from the British Library.

Designed by Liz Trovato
Photographs by Matthew Fuller

Printed and bound in China

CONTENTS

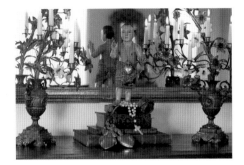

INTRODUCTION

I AM AESTHETICALLY OBLIGATED TO
SHOW THE WORLD BEAUTY NOT OUT
OF VANITY AND NOT BECAUSE I WANT
TO BE BEAUTIFUL, BUT BECAUSE THE
WORLD NEEDS BEAUTY—EVEN WHEN
THE WORLD IS NO LONGER AWARE OF
ITS PROFOUND LONGING FOR IT.

MERET OPPENHEIM

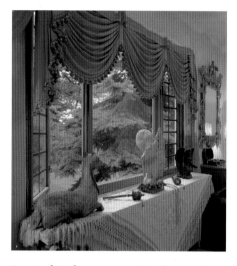

No "style" of design could be more diverse in derivation or profound in meaning than a Spiritual Style. It encompasses every world religion as well as nontraditional spiritual practices. Its images draw upon myths, symbols, forms, and works of art. It addresses the temporal and the eternal. It accommodates ritual activity and embraces the elements of nature.

Whether abundantly decorated or austerely refined, rooms designed in a Spiritual Style are meant to elevate the spirit. Often they are filled with meditative light, exalted imagery, soothing color, or reflective finishes. They are enriched with symbolism and personal content. They provoke curiosity and stimulate insight. They offer comfort and reassurance. They enhance power. Rooms designed in a Spiritual Style leave a lasting impression on the eye and in the heart.

Most styles of design are easily definable and readily recognizable. A Neoclassic room, for example, draws its elements from the refined vocabulary of the Greek and Roman periods with exotic woods and gilded ornament based on mythological imagery. A room in French Country style, on the other hand, derives its essential look from the Provence region, embracing the hand hewn and the rustic. Even a style as unbounded by geography or time as the "Romantic Style" can be defined by its frank indulgence in sensual pleasures.

In contrast, a room designed in a Spiritual Style primarily expresses its owner's relationship with divinity. It takes the most mystical of subjects—whose history reaches as far back as the beginning of time—and gives it a place in the home.

A book project is an embarkation into a world that is partially known, but mostly to be revealed. Matthew Fuller and I set out to shoot this book without any real plan. Seeking houses, we were guided by my Rolodex and referrals from my friends and colleagues. We were looking for the kind of beauty the writer Clarissa Pinkola Estes defines as "the shape of the soul."

Our mission was to reveal that soul—the spiritual function or context of each house—through lighting, composition, and the selection of objects for each image.

Above: *The bedroom windowsill of Maria McKenna and Mark Austin serves as an altar.*

Opposite: *A painting by Bonnie Cox establishes a reverential mood in Laura Cerwinske's home. Photograph by Steven Brooke.*

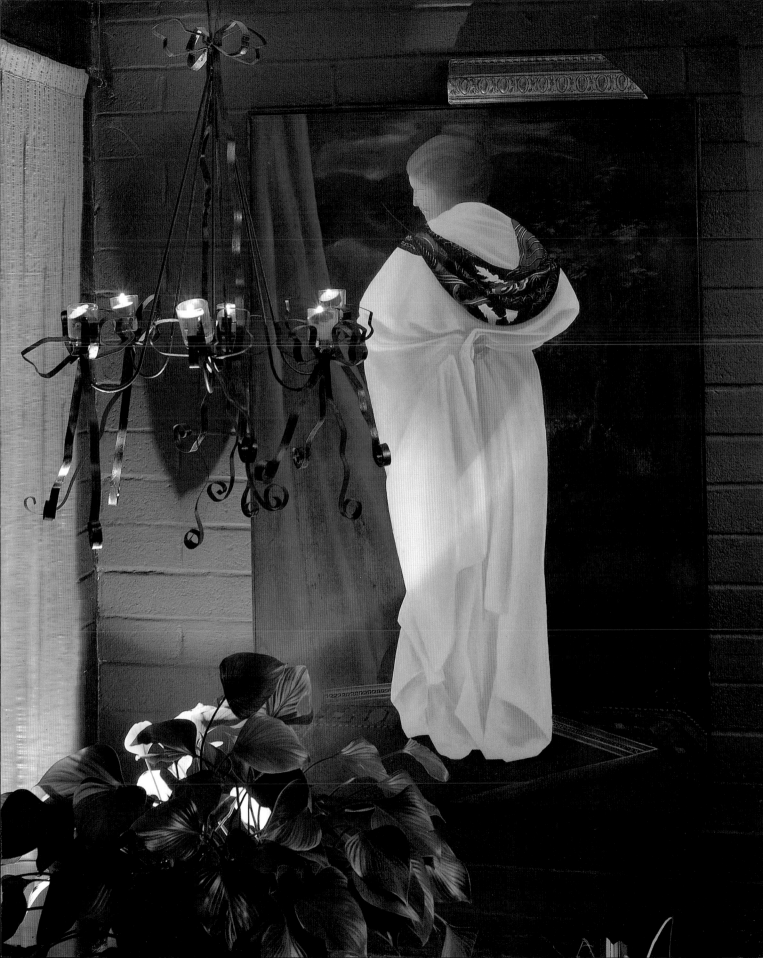

Our only requirement for selecting locations was to include a number of rooms where actual religious observance was performed. All our choices were governed by intuition and eye.

We understood that a house which might be a glorious example of domestic design or a showcase for a great collection—even of religious art—did not necessarily express a spiritual sensibility. To the contrary, many places we shot would never have been selected for an interiors showcase or design publication. Rather, their magnetism derived from the homeowner's passion and the setting's personal meaning. Each room and piece within it had to hold some symbolic or ritualistic connection to a higher power, or a system of belief.

Take for example the home of the artist Richard Warholic. Even with its furniture shrouded in sheets (in preparation for a trip to the Far East and Indonesia), his living room reflected the artist's personal philosophy: "Since I've become a transient, I'm learning to live around the pieces in my house, to be less possessive. I'm coming to believe that what you take away is far more important than what you add — at least at this point in my house, in my art, and in my life. After all these years of intense collecting and arranging and ornamenting, I'm now far more interested in reduction, in purity of form and place — certainly a very Eastern concept. Hurricane Andrew taught me this lesson in a very dramatic way. Before the storm, every inch of the house expressed my eye, my consideration. I couldn't breathe from the beauty. When the hurricane struck, everything that was trapping me blew away."

In certain houses we were greeted by a wealth of ritual objects, religious artifacts, or icons, such as the New York apartment of a professional couple devoted to collecting tribal art. What affected us about this home was not only the love lavished on the collection, but its purpose: the couple surround themselves with the artistic expressions of deeply spiritual cultures as a means of broadening their own spiritual experience. Their passion is so great that art objects fill every available inch of the apartment— including the guest bathtub, kitchen counters, and bedroom headboard.

In other houses, the setting or objects that attracted us were of purely personal sentiment. Artist Richard Warholic's Everglades City house is a treasury of fine art and found objects, all in various states of imperfection. After a lifetime of obsessively orchestrating his environment, Warholic had come to not only appreciate, but embrace the flaws in his work and his surroundings. "The flaw is the key to my work," he says quite simply. "The wound opens everything. It allows you to enter the room, just like it allows you to enter the art. I understand now—after Hurricane Andrew turned me into a virtual transient—how perfection is static, how it prevents the beholder from

entering . . . and the artist from joining the disorder where the greater truths lie."

This insight became thematic. We entered many houses that "looked" imperfect only to find a deeper beauty. We became fearless about "entering through the flaw" and embraced the concept as a means of apprehending essence. Matthew adapted the theme to his photographic philosophy. He felt that the way to see the settings in their "truest" light was to allow the rooms to "give me the light that was there rather than imposing a standardized type of lighting on them." Our first shoot confirmed how photographic lights made the pictures feel contrived and impersonal, the antithesis of the meaning of this book. From that shoot on, Matthew used what was available—table lamps, floor lamps, windows, and reflections. As a result, most shots required long exposures, which means they are more effulgent—literally, light-filled—than a strongly lit short exposure.

The greatest of our many discoveries on this creative odyssey was how many people imbue their lives with some spiritual aspect through ritual and art, or otherwise invoke higher powers. We found people who considered their homes to be sanctuaries for others, to be places for gathering and celebration, for worship, for memorial, even for burial.

We were graced with the pleasure of working within an atmosphere of trust. Homeowners who had never met us before welcomed us into their rooms and let us handle everything from prehistoric museum-quality ceremonial objects to priceless personal mementos. For some, our work allowed them to see their homes and their possessions with fresh vision.

Artifacts of various religious practices find their home among the shrouded furniture in Richard Warholic's living room. On the bench stand a 19th-century Guatemalan santos, a Guatemalan Indian box with fertility symbol, and a shaman's tortoise on which herbs are laid to be burned. The belief is that the tortoise takes the shaman's prayers to the gods in the smoke of the burning herbs.

One of the great rewards of a spiritual life is the ability to enter the unknown with joy and confidence. This was how we approached the creation of this book. Robert Strell, who regularly employs design books such as this in his architecture practice, describes their value as "resources you can endlessly revisit. They take me to places I want to be and offer me pictures I never tire of."

We intend this book to provide a continual source of visual and spiritual inspiration and hope that it will bring joy and confidence to all its readers.

THE EVOLUTION OF SACRED DESIGN

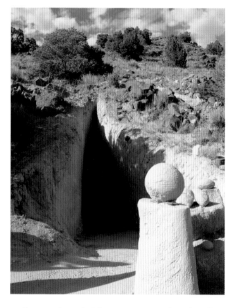

Imagine earliest man and woman, alone and unsheltered, begging protection from the unfathomable divine with rituals, offerings, and invocations. Their obeisance would have been paid to the stars and planets, the animals and plants, the lightning and thunder, to all the deities of nature and the four elements.

For the first two million years of our existence on earth, humans survived by gathering, hunting—and worshiping the goddesses and gods of nature. The development of farming—and agrarian deities—occurred only about 10,000 years ago—relatively recent in evolutionary terms.

Throughout many African and Eastern cultures, various forms of goddess and nature worship have endured and evolved since Neolithic times. In the West, theocracies and patriarchies based on the worship of gods and saviors grew from the time of the Greeks. The institutions into which they evolved, representative of a small fraction of the history of human worship, form the primary religions practiced in the West today.

A simple pile of rocks is likely all that comprised the first sacred monuments. The stones, valued not for their durability, but for their concentration of earth energies, would have represented a shrine to the earth goddess. Even a single sacred rock or piece of comet fallen to earth could conjure up and communicate the power of the divine, enabling the worshiper to see the invisible, to experience the impalpable.

Early monuments also were intended to reflect the cosmos and were aligned with the heavenly bodies. The matriarchal or Great Goddess religions created monuments to the moon, for example, because its cycles were associated with agricultural, tidal, weather, and hunting cycles as well as with women's bleeding and fertility.

Anthropologists Judith Hoch and Anita Spring describe one goddess site where "reflections of the full moon on the subterranean water at the time of the annual first

A cave dug by Ra Paulette, above and opposite, is an homage to the Earth Mother.

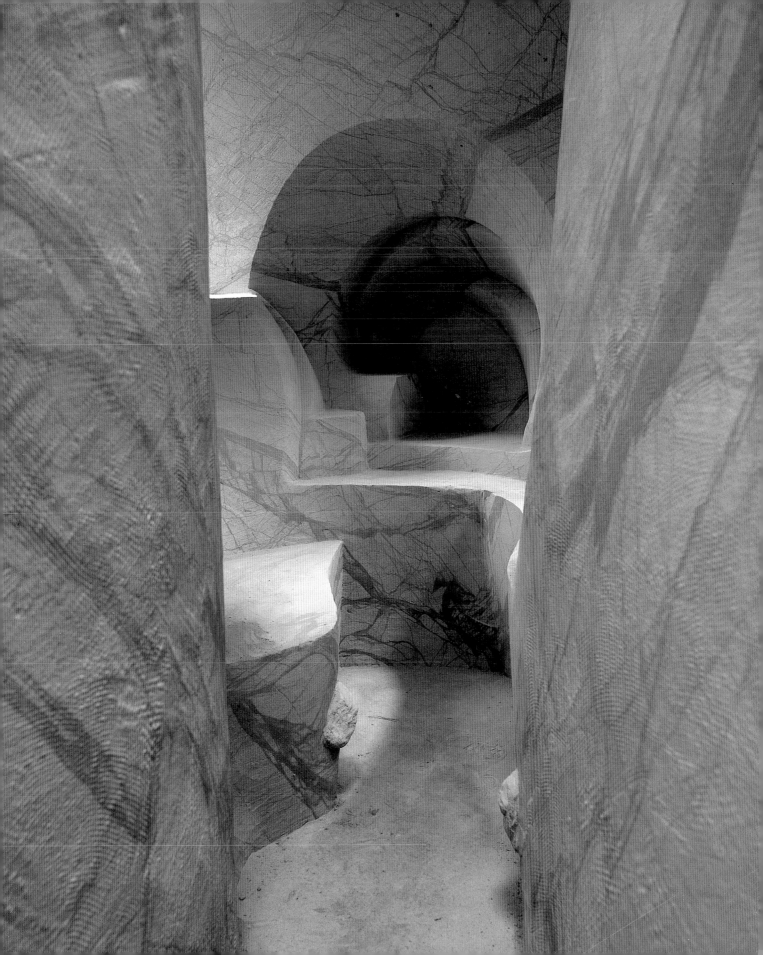

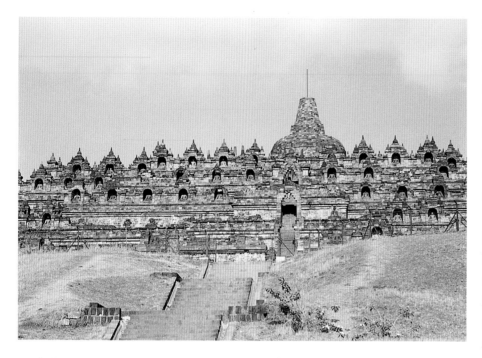

Borobudur, in Java, Indonesia, is one of Buddhism's most revered sites. It was built between 750 and 850 A.D. Photograph by Grace Young.

fruits ceremony display the birth of the Divine Harvest Child. The hill synthesizes meanings from the cult of the Goddess: the dynamic processes of the fattening of the moon, the transformation of corn from green to gold, and the stirrings of the unborn child, which are linked together in universal cosmic rhythm."

Fertile places were considered holy—and healing. A soil-rich riverbank or the verdant land surrounding a spring or well made an appropriate site for purification rites and baptisms. Caves, hidden grottoes, isolated hills and mountaintops, on the other hand, provided the secrecy required for prophecy.

Eventually, many systems of prescribed geometry were applied to sacred architecture. Solomon's Temple, 965 B.C.E., was an early example of this tradition which extends through antiquity to the pinnacle of Christian high architecture, the 12th-century cathedral at Chartres. The Jewish Tabernacle, the Athenian Parthenon, the Muslim Ka'aba at Mecca, and the Aztec sun temples are other examples.

In ancient Egypt, temples were intended as images of divine creation—the floor representing the earth, the ceiling representing the sky and the heavens, pools and fountains representing springs, seas, and rivers. Statuary of goddesses and gods, crowned and armed with divine emblems, blessed, protected, and reminded worshipers of the deities' powers.

In ancient Greece, the temples were considered the dwelling places of the goddesses and gods. Their presence was signified by a statue, a mystical symbol, or an invisible oracle. In Greek myth, the first images of the goddesses and gods were made by nine wizard metalworkers of Rhodes, known as the Telchines, whose craft was so great that their statues were taken for living beings.

The Romans, too, created monumental imagery in honor of their deities—sculptures in the round and in relief as well as exquisitely painted frescoes. Centuries later, Christians carved, sculpted, and painted literal images for display throughout their churches, surrounding the worshiper with illustrations of the glory of the Savior, the lives of the saints, and depictions of the path to heaven—or to hell. The

gold-domed churches built by the emperors of Byzantium with their jewel-colored mosaic walls were designed to envelop the worshiper in a sensual ecstasy. Their successors, Christian Orthodox churches, surround the worshiper with incense, music, and candlelight glittering against a background of gilded icons.

Judaism and Islam, unlike the Christian religions, have no specific visual traditions of sacred architecture. Since the destruction of the Second Temple in Jerusalem in A.D. 79, the Jews have been sustained by the holiness of the family rather than the holiness of one building. The notion of "the temple" was nourished with observance in the home and congregation. The original altar of sacrifices in Jerusalem was transmogrified as the dining table of every Jewish home. The sacred Torah, which once was read only in Jerusalem, was replicated and placed in an ark in every Jewish community throughout the world. The Holy of Holies, the innermost sanctum that represents the Temple, is considered to be in man, rather than of man.

In Islam, the five basic precepts of the religion—faith, prayer, pilgrimage, fasting, and charity—are conveyed architecturally through syntheses of numbers, lines, shapes and colors. These are intended to provide the awakened soul with means of expression.

Islam decrees that the human body, which is animated by the same energies as the cosmos, is the temple. Its mosques, therefore, represent the cosmos. The Ka'aba is the most holy shrine of Islam and contains a stone, possibly from a meteorite that fell from the sky. The shrine, covered by a monumental black cube, acts as a focus for the eight lines that radiate to the cardinal and intermediate compass points.

The design of Buddhist monuments, variously called stupas, chortens, or chedis, is based on the perfect proportions of the Buddha's body. The earliest stupas, of Indian and pre-Buddhist design, were intended as shrines marking the places consecrated by the Buddha: his birthplace, the site of his Enlightenment, the place where he gave his first teaching, and the place where he died in the fifth century B.C.

Many stupas were built throughout the East as receptacles for offerings and as tombs for great spiritual masters. Their design was strictly defined: The foundation required a square base denoting the earth and a dome symbolizing water. A flight of stairs, representing both fire and the steps of Enlightenment, ascended to a stylized umbrella, emblem of the wind. This was sometimes crowned by a five-petaled lotus flower. The stupa culminated in a crescent moon on which a solar disc was mounted, expressing the cosmic supremacy of the Buddhist Law.

Hindu worship centers on direct visual and physical contact with the divine. Temples and shrines to each and every deity fill the religion's sacred landscape. In the heaven-reaching temples of South India, for example, bronze images of the deities are "treated like the next of kin who just happen to be kings and queens. Gently put to

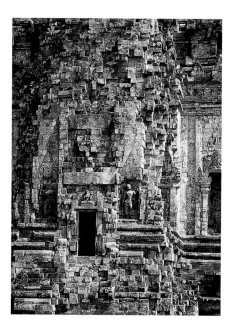

bed at night and awakened with music at dawn, they are bathed, dressed in fine silks, and rocked in swings by the temple pool," describes the writer Marina Warner.

Today sacred design is found in every form, from soaring architecture to modest store fronts, and from glass cathedrals to kivas. Ritual, too, is performed everywhere, from temples to gardens to private homes. Established religions continue to change just as new spiritual practices incorporate traditions. With the realization that worship exists wherever the soul seeks communion, we recognize that the true sanctuary is of our own making.

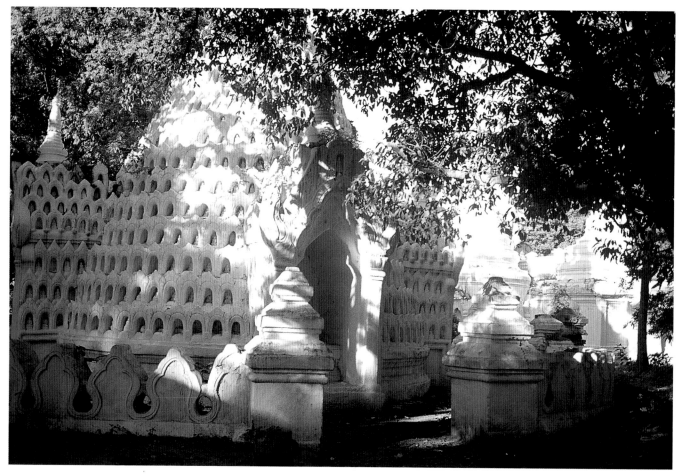

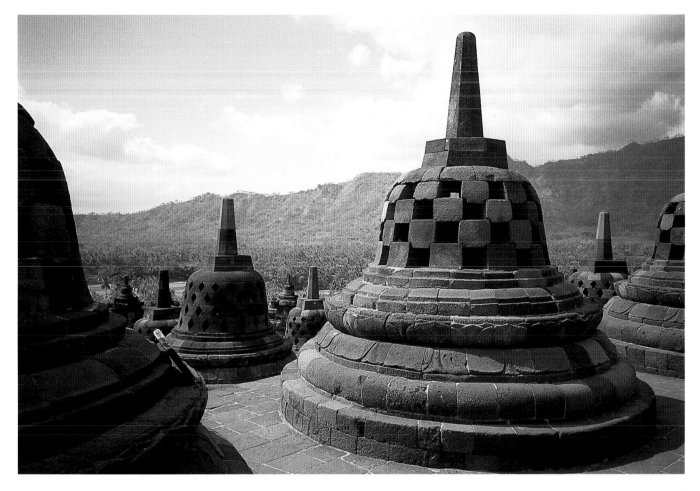

Opposite, top: *A detail of an Indonesian temple.* Bottom: *A partial view of a temple in Myanmar.* Above: *The stupas at the top level of Borobudur represent enlightenment. At right: Prambanan, the 9th century Hindu temple in Java, is dedicated to the god Shiva. Photographs by Grace Young.*

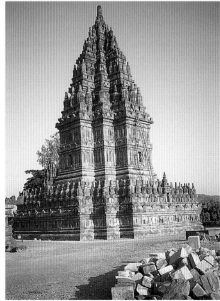

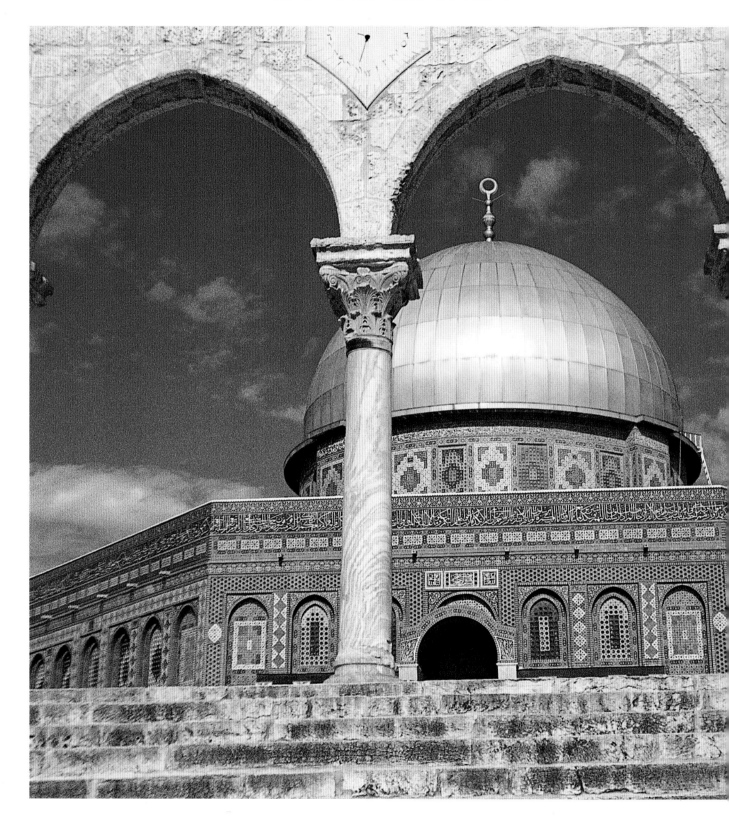

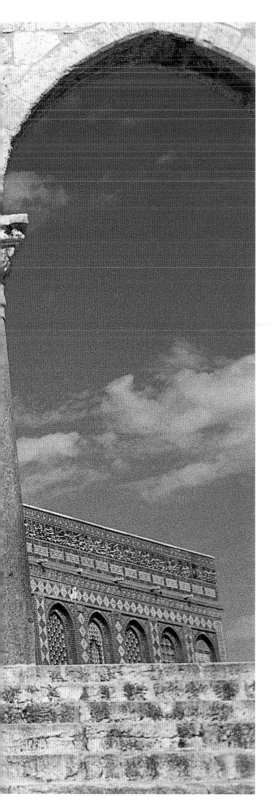

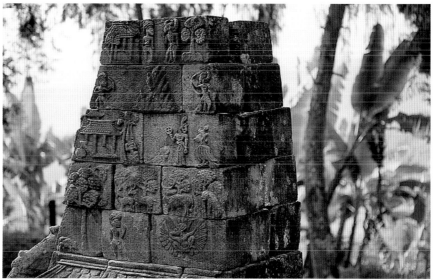

Above: *Detail of a temple in Indonesia. Photograph by Grace Young.*
Left: *The Dome of the Rock in Jerusalem, one of Islam's sacred sites. Photograph by Robert Strell.*

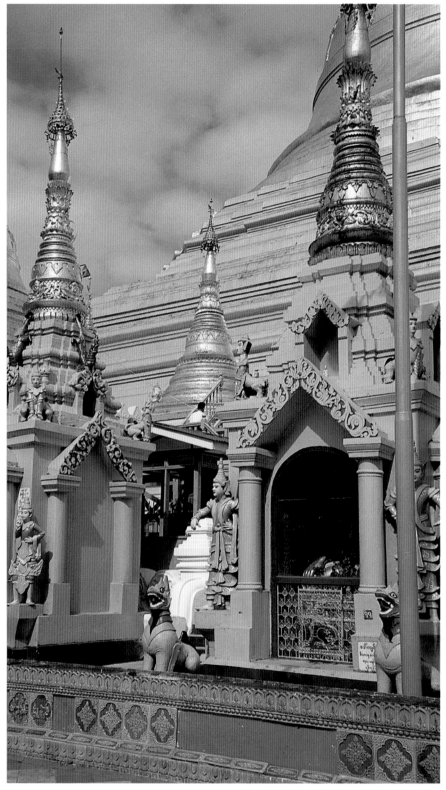

Details of Buddhist temples include that of Shwedagon in Rangoon, right. Photographs by Robert Strell. Opposite is Stabat Mater, the Thirteenth Station of the Cross, in the Church of the Holy Sepulchre, Jerusalem. Photograph by Steven Brooke.

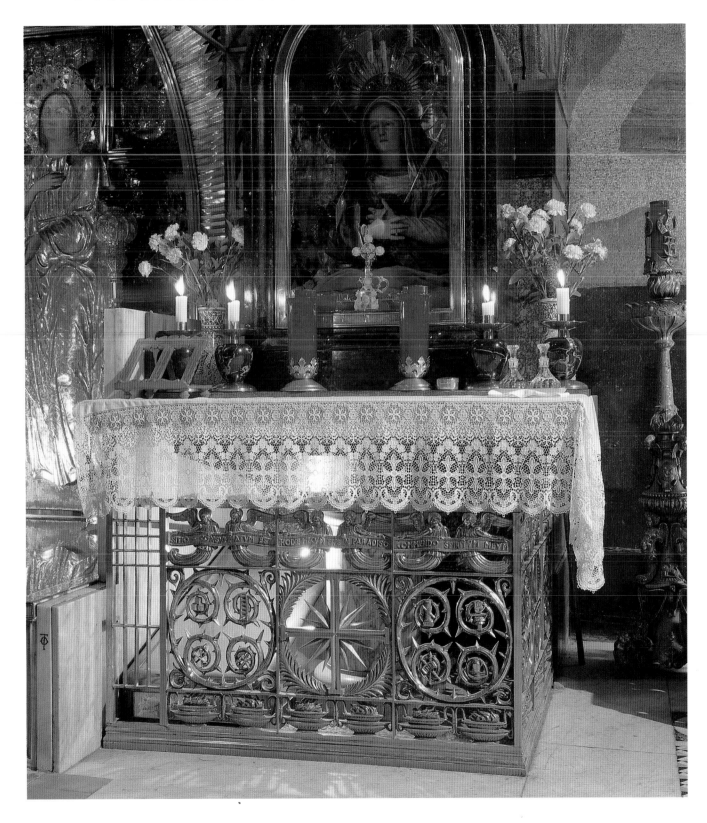

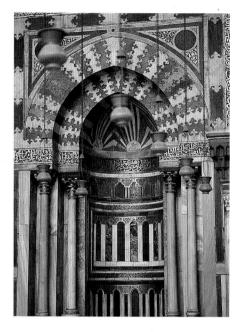

Above: *An Islamic mosque in Cairo. Photograph by Grace Young.* Right: *The Chapel of St. Helena in the Church of the Holy Sepulchre, Jerusalem. Photograph by Steven Brooke.*

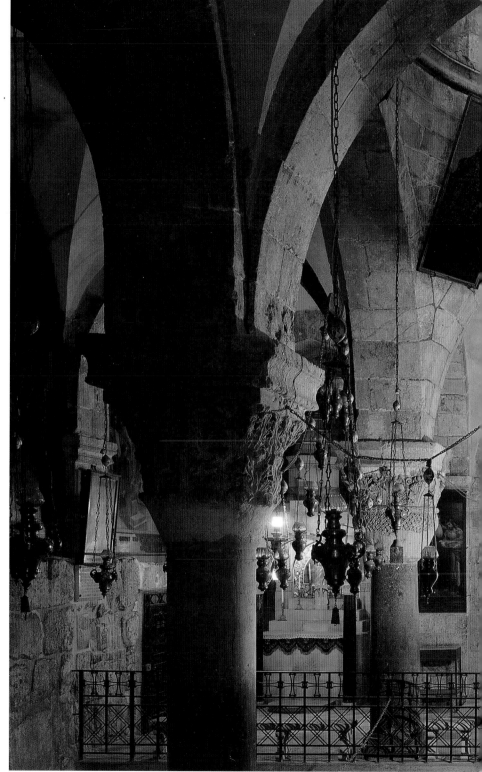

THE MEANING OF SANCTUARY

The omnipresence of books in many Jewish homes creates a sense of sanctuary as strongly as the presence of "religious" artifacts. Judaism is the only religion that ritually celebrates the beginning of the reading of a book—the Talmud—and completion of its reading.

Included in Maria McKenna and Mark Austin's piano-top altar to their ancestors are a photograph of the McKennas' family friend Arturo Toscanini, far right, and Uday Shankar, brother of Ravi Shankar, at left, who urged Maria's mother to give the future ballerina dance training. In the background is a bas relief of the Four Muses.

For many people, a sanctuary is a place of order and tranquillity, a retreat from the disharmony of the world. For others it is a place to be creative, to seek meaning in life, to do the work of transformation that, at times, calls for descent into pain and chaos. A sanctuary provides a safe place to dance with the devil, to embrace lurking shadows on hallowed ground.

A sanctuary is as much designed to inspire animation—*anima* being the Latin word for spirit—as to nurture stillness. It must provide whatever form the need for communion requires. A home becomes a sanctuary when it protects the life and nourishes the spiritual visions of all the souls who dwell and are welcomed within it. The home also becomes a sanctuary when it nurtures the integration of body, mind, and spirit.

The integration of body, mind, and spirit is paramount to Maria McKenna and Mark Austin, whose secluded Westchester County house is set in a woods forty minutes north of Manhattan. This combination of proximity and remove is crucial to the sense of balance the couple ardently protects. The sanctity of their home also derives from "its connection to the mineral kingdom, the animal kingdom, and the botanical kingdom." Rock outcroppings underline the geological ancestry of a site, inhabited centuries ago by Native Americans, which the couple maintains as a nature and wildlife preserve.

The house contains "all the things we love—the books, and art, and objects, and musical instruments and photographs that nourish our passion and sustain our health and growth." Many of these objects are gathered atop and around their piano, making it both an altar and a site for congregation. Elsewhere in the house, they have installed angels in three of the four compass points. The east-facing angel, carved in stone relief at the top of the entrance facade, is "our symbol of divinity, looking out over us and whoever enters our sanctuary."

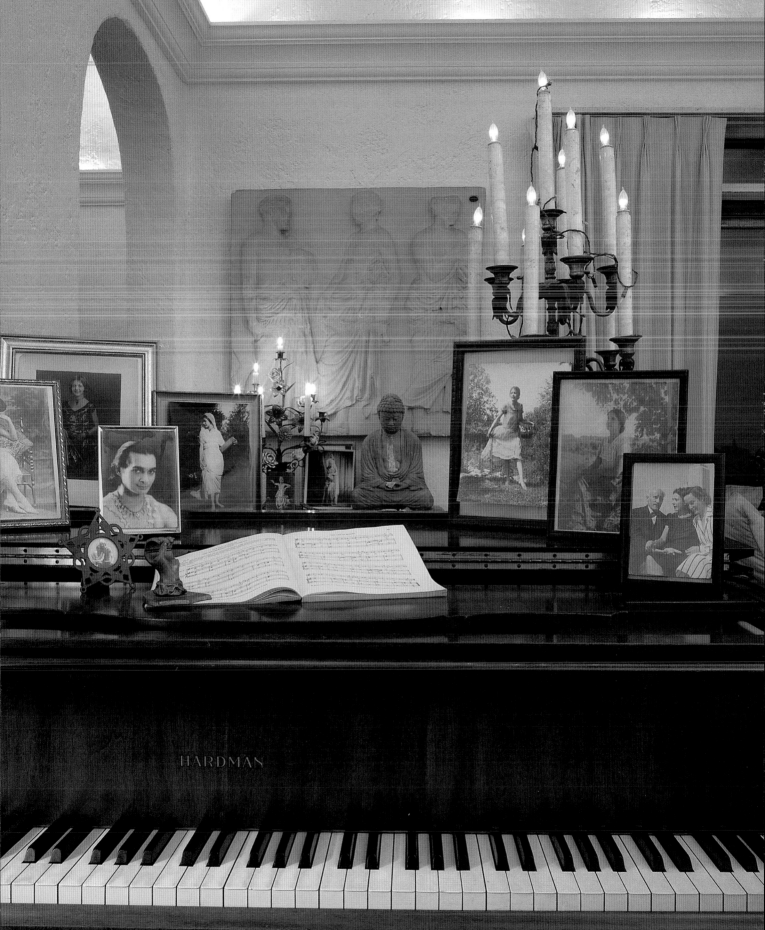

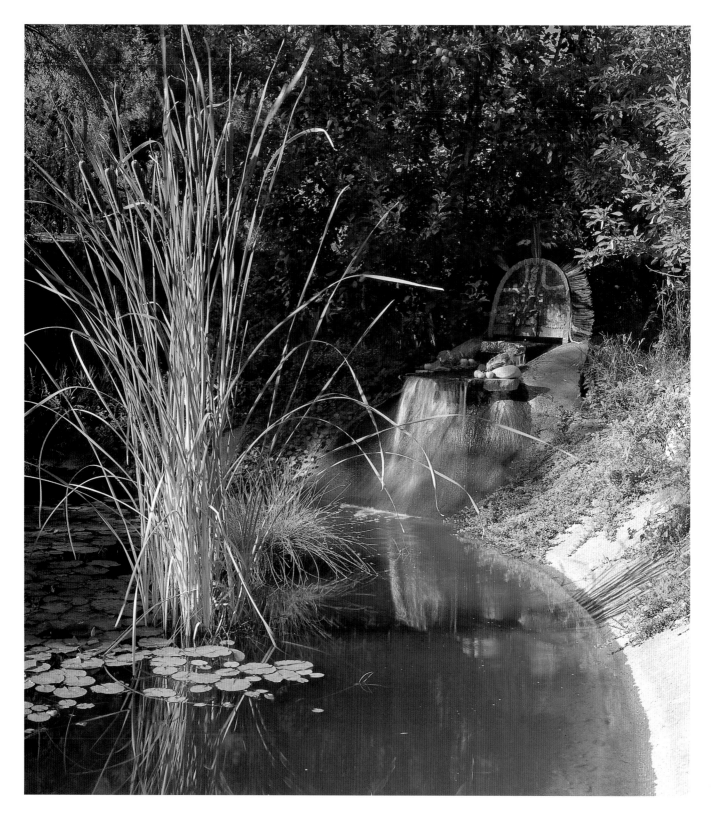

The residential garden is often a sanctuary endowed with personal meanings. The author John Beardsley writes, "The domestic garden is often where private speculation makes its first appearance before the [outer world], where a person begins to define a conception of nature. It is a place of inquiry and moral assertion."

Garden sites that encourage such meditative practice center on the elements: water trickles over rock in a Zen-like setting or reflects the utter stillness of a pond; leafy shade trees provide shelter for contemplation; a wildflower garden memorializes departed friends. Albuquerque architect Robert Strell's garden has evolved over twenty years into a sanctuary for

Hindu Shiva and Shakti figures look out over Long Island Sound from Wainwright House, a former private mansion that is now a spiritual teaching center in Rye, New York.

his friends and family as well as for himself. They come to celebrate, to heal, and even to be buried. The ashes of five friends are scattered in the pond and garden. At Joe and Sharon Ely's Austin homestead, artists, animals, musicians, and family find refuge in the shade of sacred oak trees hundreds of years old where various tribes of American Indians once gathered.

The spiritual resonance of Robert Strell's meditation pond is enhanced by the lotus flowers and bullrushes growing in it. The lotus is a universal symbol of spiritual unfolding—rooted in mud, resting on the waters of repose, blooming in sunlight. The bullrushes refer to the biblical story of Moses.

Sanctuary and ceremony are inextricable. One such sanctuary is the Jerusalem apartment of Tirza Moussaieff (page 28). Designed as an homage to her Bukharan ancestry and to her ancestors' long tradition of commemorating the seasons, it is an oasis of color, filled with the vivid reds, blues, yellows, greens, and oranges of her Central Asian ancestral home. Bukhara, which was, until 1989, a part of the Soviet Union, is an agricultural oasis where some of the world's most delicious fruits are grown. Miss Moussaieff recreated its verdant sensuousness by surrounding herself with the colors and textures she associates with that country as well as with a prodigious collection of Bukharan porcelains.

Her exquisite ceremonial pieces are used today as they have been for centuries, to celebrate the bounty of the earth in its various seasons. Two of the most common decorative patterns display images of cotton and of grapes, primary Bukharan

The garden sanctuary is also a place for study, contemplation, and private remembrance. In the Ely garden, the spiral steps and gazing globe represent the ascending path to enlightenment. At right is Sharon Ely's memorial to a family friend.

crops whose harvests culminate with festive rituals. This sense of festivity extends into Tirza Moussaieff's hospitality—tea is poured from ceremonial teapots and fruit is served on Bukharan plates bearing traditional ikat patterns and colors.

Ikat is an ancient weaving technique that was revived by artisans of Bukhara and Samarkand in the early 19th century. Its blurry-edged floral forms, geometric motifs, and peacock feathers are created in a process that involves wrapping sections of silk yarns with cotton threads to block the dye from penetrating the yarn. The images emerge in the weaving. The effect of a highly refined textile technique reproduced as pattern in porcelain further heightens the drama of Tirza Moussaieff's ceremonial "table settings."

Tribal artifacts from all over the world fill an apartment in the urban setting of Manhattan (pages 30 and 31). The owners, a married professional couple, like to think of their home as a "shrine to human culture." "We feel comforted by religious, emotional, and artistic expression," they explain, "and by being surrounded by pieces that bring their creators' lives into ours. They are more than beautiful sculpture—they are manifestations of humanity reaching out for something intangible, untouchable."

The couple's collection covers walls and surfaces of every room, even the guest bathroom where fetish figures from Zaire and a Guatemalan mask are displayed on a platform in the bathtub. In the hallway, raincoats hang below a display of Himalayan masks and a shelf of 19th-century Sumatran ceramics. In the bedroom bookcases hold African masks, and over the desk sits a nearly lifesize Tau-Tau—a protective figure from Toraja-Sulawesi, carved when a person of nobility dies.

The couple is drawn to witness "the many manifestations of the human mind," with art that serves to "open up our world view and enable us to think more broadly about people's conditions." Was a certain piece used by a family or shared by a whole village? How long did it take to create? And what happened to its creator? They find that the spec-

ulation, fantasies, and the education they've gathered in their research and travels nourish them psychologically, culturally, artistically, and spiritually. "The art works enable us to feel as if we're keeping a part of these cultures with us, in our home, at all times."

Inner exploration, personal expression, ritual, and remembrance are intrinsic to the life of an artist. The devout artist is, by nature, a person of idiosyncratic genius, tenacious faith, and unalienated labor. It is only natural, then, that his or her home reflect the qualities of spiritual process.

Miami artist Richard Warholic's house is a "working aesthetic." Its whole point "is to inspire me. Wherever I look, everything is orchestrated to engage me. I continually discover visual effects that energize me. The patterns of light and shadow falling across the rooms affect me like visual mantras."

It took the artist a good part of his lifetime to discover how less can be more—both in his life and decorations. The discovery occurred on an almost epic scale—a

In a Jerusalem apartment, candles commemorate the Sabbath while flowers reaffirm life. Photograph by Steven Brooke.

direct hit to his house by Andrew, the 1992 "Hurricane of the Century." The 70-year-old wood frame cottage, built of Dade County pine, survived; but Warholic's fastidiously cultivated garden surrounding it and the furniture, antiques, heirlooms, and art work inside it were destroyed. Richard Warholic discovered that out of a void left by devastation, a new sense of beauty can emerge. "Before the hurricane, every inch of the house expressed my eye, my consideration," he says. "I couldn't breathe from the beauty. Then with Andrew, everything that was trapping me blew away. Now I sleep in that bed. I sit in that chair. I spend hours a day motionless, simply observing—discovering the wildness I was always trying to tame."

Warholic describes his sanctuary as "luxurious—in that it is filled with objects that resist selfishness. It interacts with people. It teases you. There are boxes and cabinets to open up, objects to pick up and hold, portals to peer through. The house is like a cat—it likes anyone who feeds it."

So simply and gracefully proportioned are the architectural elements and furniture that even when given their "summer sheets," the rooms retain a sculptural beauty. The spare assortment of decorative and personal items—an 18th-century crucifix, a Renaissance-style marble urn, and shamanic artifacts—are all the more inspiring in their singularity.

For the worshiper or artist cast into exile, the sanctity of home is all the more cherished. Collectors Dina and Jeffrey Knapp consider their Miami Beach house a refuge for visual art of the diaspora—the world outside the spiritual, cultural, and artistic mainstream. The house (pages 36 and 37) is filled with the colorful, playful, and fantastical imagery of Haitian art and outsider art. Like Richard Warholic's house, it has evolved to provide its owners a perpetual source of inspiration. The house connects the couple to their artistic souls and, surprisingly, to their Jewish heritage.

Cartoonish faces of Satans and saints, horned mermaids, and sequined Madonnas observe the activity of the household from every wall and table top. These subjects represent the Haitian animist world in which African deities are incorporated within Catholic imagery. The couple believes that growing up with a strong ethnic identity makes any ethnicity feel in some way natural. The uninhibited childlike expressiveness of the beaded banners and painted figures impart a joyful sanctity into the light-filled rooms.

"When you enter the Church of the Holy Sepulchre or Notre Dame, you simply want to light a candle," says Dina Knapp. "That transcendent gesture cuts across all parochial lines. Religions all get to the same place. I want my home to transport me like those holy sites do."

"Our Jewish heritage emphasizes textual interpretation as art—disciplines like creative writing and the music of liturgy," explains Jeffrey Knapp. "As religious individuals and visual artists, we respond to religious cultures that incorporate visual objects. From the moment we first saw this work, we had to live with it."

A "household god" created purely from the artist's imagination is stationed outside Beverly Magennis's Albuquerque house.

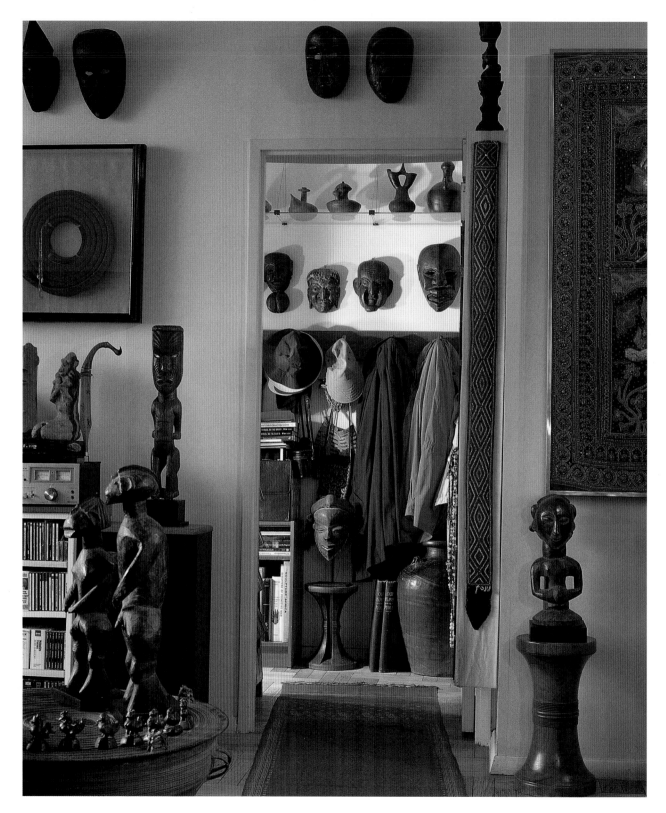

The Knapps consider themselves amassers rather than collectors because they view the presence of art as a necessity. The amassing represents "the complete weaving of all aspects of our lives." They count as friends many of the artists whose work they buy, and they value those friendships as integral to the art. "Those outside your traditional experience can teach you in ways that those familiar to you never could," says Dina Knapp. Of the artists and the art she adds, "I become their child."

The traditional Jewish home is a sanctuary for family life, contemplation, study, and prayer. Most important, as Abraham Joshua Heschel describes, it is the place where the Sabbath observance begins as Jews "turn from the world of creation to the creation of the world, and lavish care for the eternity planted in the soul."

Even an incomplete interior can serve as sanctuary. Despite the unfinished condition of a house owned by an antiquarian (pages 38 and 39), the Sabbath is nevertheless honored with exquisite formality. This Friday-night ceremony pays homage to the belief that a sanctuary must have light—to symbolize the divine—and bread—to distinguish humans from animals, who cannot make their own food for sustenance.

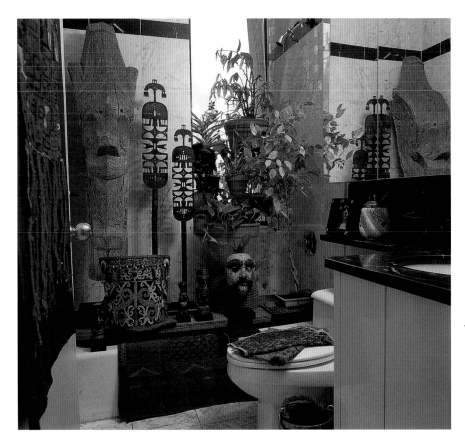

In a Manhattan apartment is a Kusu figure from Zaire on a Javanese stool in front of a Burmese tapestry. Above a Sumatran beaded baby-carrier belt is a small Hampatong ancestor figure from the Bahau tribe in Borneo. Above the door are Sumatran masks. On the floor is a 19th-century Sumatran wedding ikat. A glass shelf holds 19th-century Sumatran ceramic pouring vessels and a 14th-century Javanese example. Below them, Himalayan masks. On the floor are a 15th-to-16th century Martaban jar, and a mask from Zaire. In the foreground is an 18th-to-19th century bronze drum from Laos holding a collection of antique Burmese opium weights and a pair of figures from northern Nigeria. On the speaker is an early-19th-century stone carved Maori figure. On the tape deck are a Mentawai Indonesian knife and two African terra-cotta figures. Solomon Islands currency made from the red feathers of 300 birds is coiled on the wall. Above it are two Indonesian tribal masks.

In the guest bathroom, at left, a pre-Columbian Nazca textile, A.D. 100–500, hangs on the door. Draped over the tub is an early-20th-century Burmese Akha tribal textile. On the tub platform, in front, is a Kosongo (Zaire) fetish figure, a Kyak beaded baby carrier, an Azande (Zaire) fetish figure, a Senge (Zaire) fetish figure, and an 18th-century Guatemalan mask used in a dance of Moors and Christians. In the back are an early-20th-century Sumatran singha from an exterior housebeam, and a pair of Tuareg (North Africa) poles used as cushion supports. On the toilet seat are two woven raffia cloths from Zaire.

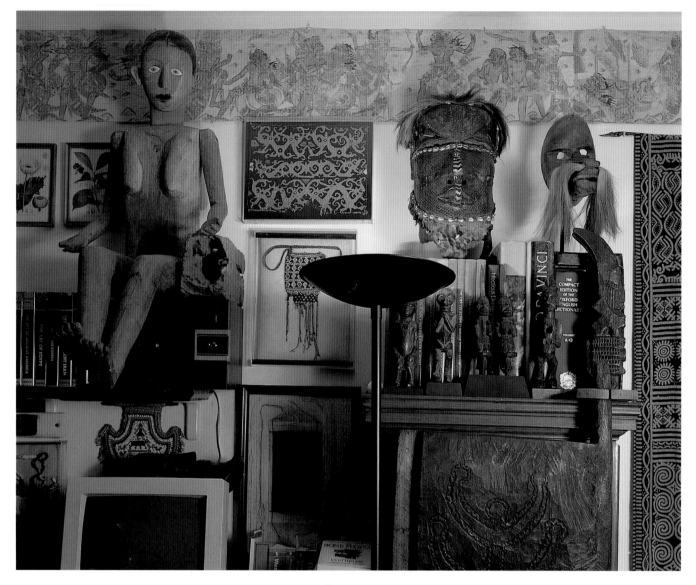

In the bedroom office area are, from left, a sacred Torajan textile hanging next to a beaked mask from the Ivory Coast and a kuba mask from Zaire. Below them are a group of small African figures. The door of the bookcase is a carved timor from Indonesia. Across the wall hangs a Balinese temple painting and, below it, a 19th-century beaded panel from a baby carrier from Borneo. Below this is a beaded bag from Timur and a headband used by Mien shamans. The wooden figure is a Tau-Tau from Toraja-Sulawesi where these figures are set into limestone balconies carved into cliffs, protectively overlooking the village.

The urn on the mantel of Richard Warholic's living room was made by Caroni Brothers, Boston, from a mold taken from a Michelangelo original. The weathered and stained bench is by Warholic. The crucifix with anguished expression was brought from Spain to the Philippines in the 18th century.

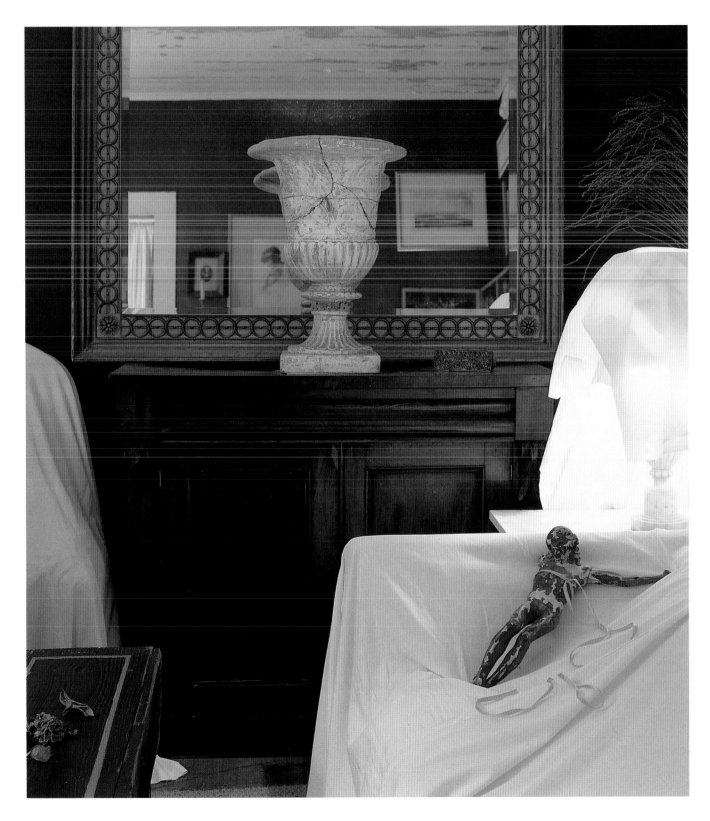

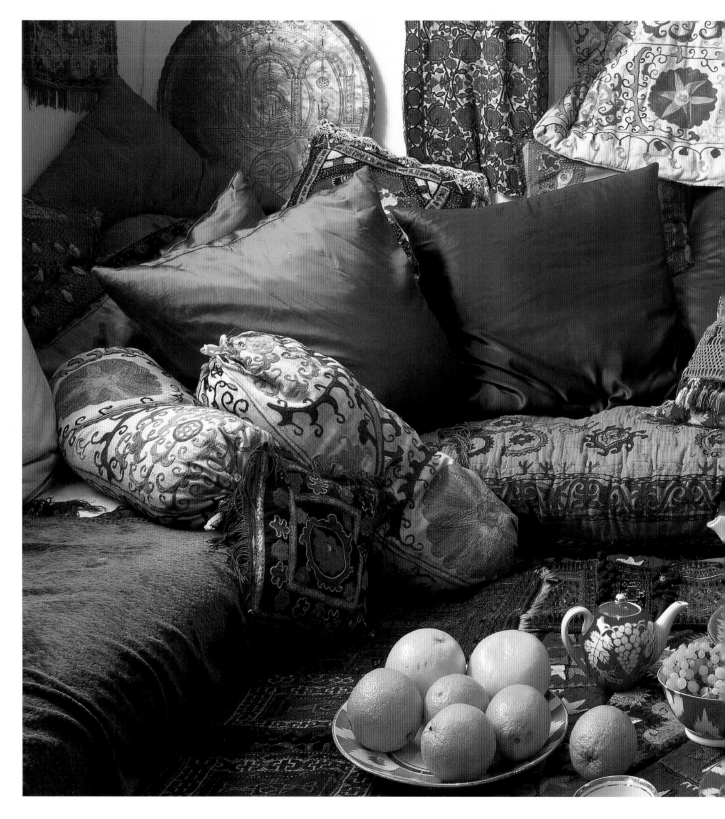

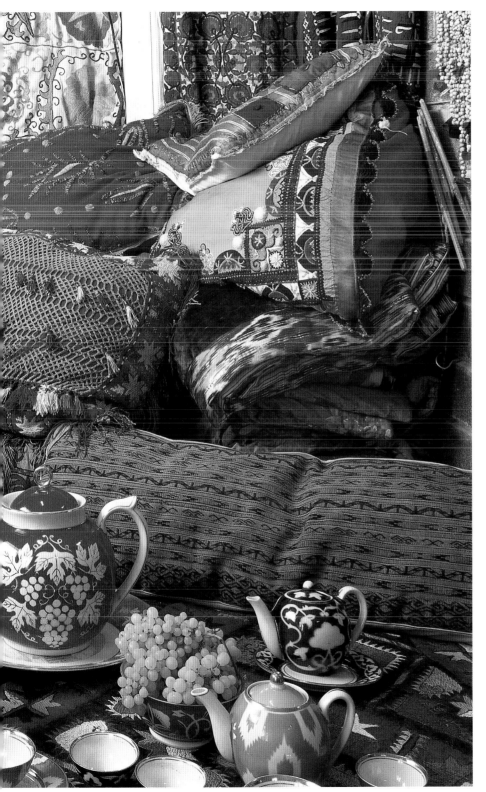

In Tirza Mousaieff's Jerusalem apartment,
Bukharan porcelain sustains a cultural tradi-
tion of seasonal commemorations. The design
on the teapot is a stylized pattern of cotton,
an important Bukharan crop whose harvest is
celebrated with a tea ceremony. Photograph by
Steven Brooke.

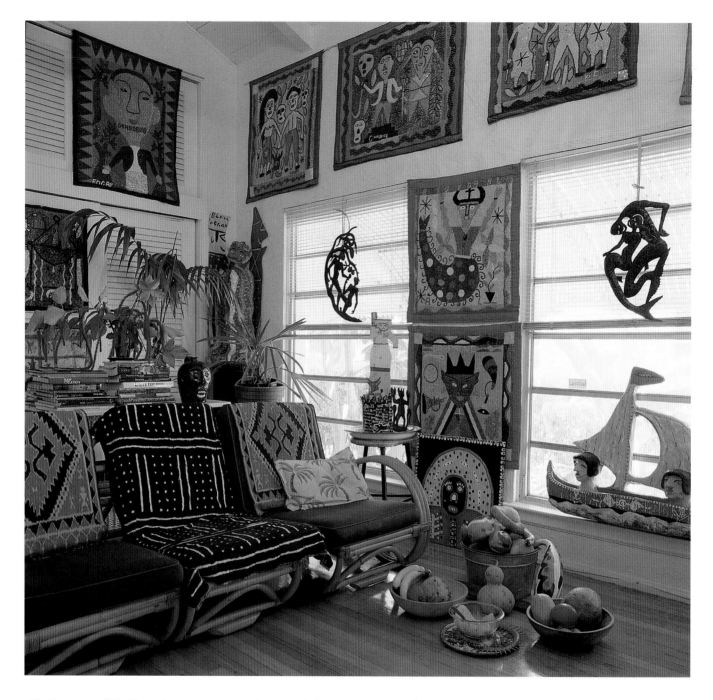

The decoration of the Knapp living room insures that it is inhabited by loas, or beneficent spirits of the voodoo world. The first flag on the left, by Edgar St. Louis, represents Grand Bwa, a forest loa who brings healing. The flag to the right, by George Valris, shows the Marasa, twin loas, which are a sign of good luck. The three Marasa on the far right are signs of even greater luck. In between is a composite of Gran Bwa; Baron Samedi, the ancestor spirit; and symbols of Erzuli and Dambala, two supreme female and male figures. The two drapos, or banners, one on top of the other, are versions of La Siren. The cut metal Devil and Blow Oscar are by Georgia folk artist R.A. Miller. The Haitian metal sculpture Adam and Eve is by Darius Gray. The papier-mâché pieces are by Michel Sanvil.

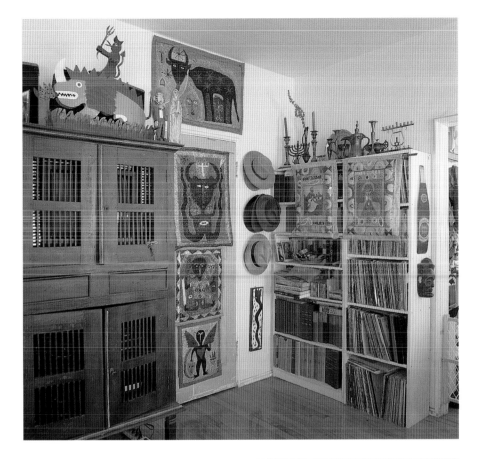

Jewish artifacts, voodoo imagery, and folk art are intermingled in the Knapp bedroom. On top of the shelves are various Chanukah menorot. On top of the armoire is a devil riding a rhinoceros by Georgia folk artist Tubby Brown. The drapos are of various spirits by Maxon, who took over the studio of Antoine Oleyant. The designs are by Oleyant and their execution by his atelier. The snake image below the hats is by Alabama folk artist Mose Tolliver.

The protective spirit of La Siren watches over the bed of the Knapps' daughter, Ariel.

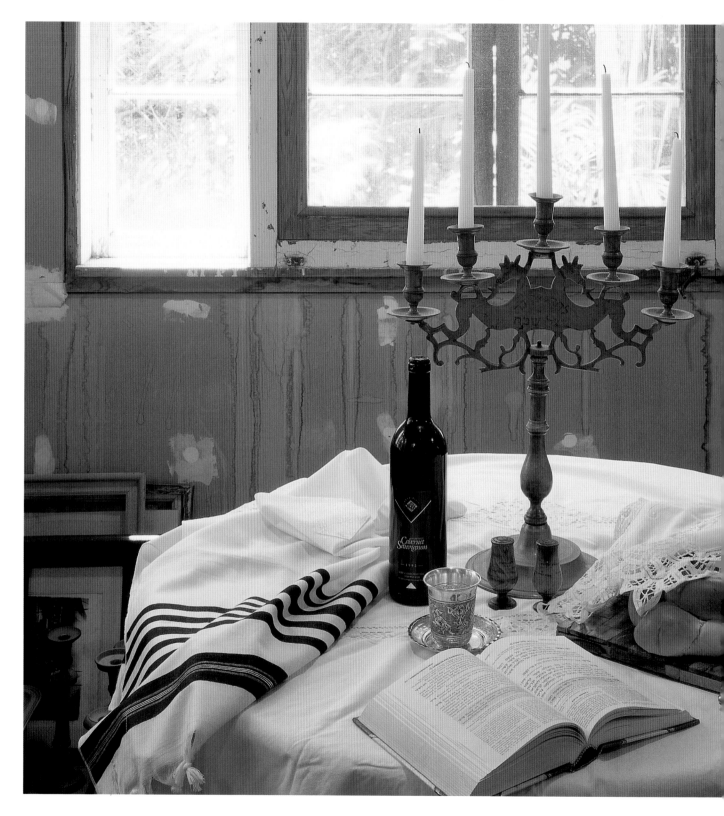

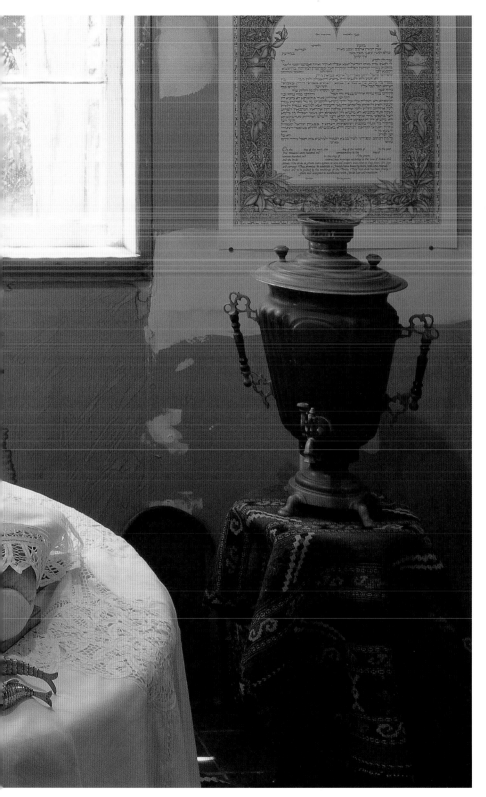

A Sabbath table is set in preparation for the ritual lighting of candles and blessing over the bread and which can be performed only by a woman. The ceremony takes place at sundown, before the serving of the meal, which is preceded by ritual handwashing. On the table, from left to right, are a tallis, or man's prayer shawl, a 19th-century brass menorah, or candelabrum, and a challah, the traditional Sabbath bread. Photograph by Steven Brooke.

SYMBOLISM

Symbolism evolved out of humanity's attempt to thwart mortality and gain power by appropriating the qualities of divine beings and worldly creatures. As Marina Warner writes: The gods are deathless, humanity dies. Birds defy gravity, fish breathe underwater, and beasts exert superhuman strength while humanity is earthbound and vulnerable to the whims of nature. Goddesses and gods exist outside time, unbound by the laws of space, while humanity is confined to the physical plane.

A lasting symbol is simultaneously universal and individual, carrying archetypal significance as it articulates personal meaning. Likewise, the symbolism attached to design elements can derive from purely personal experience as much as from historic tradition. Of course, the more readily recognizable the object and universal its meaning, the more readily its power is communicated. A crucifix or Hindu offering bowl or Hebrew prayer book brings immediate connotation to a tableau. A highly individual piece of art work or memento, on the other hand, typically requires a more concerted measure of contemplation for its meaning to be apprehended.

A symbol can arise from more than one source, being adapted over time from many different religions, ages, and civilizations. In a room, a combination of universal and personal references can be visually and spiritually potent. For example, a tableau that combines an image of the

The Mary figure embodies purity and compassion. The skull is a portent of death over which her compassion reigns. The candles symbolize eternal light, and the nest with egg and pear represents the sweetness of the promise of salvation. Photograph by Peter Vitale.

A 19th-century Mexican foot amulet to which representations of other body parts, called milagros, are attached takes on sculptural presence in an Albuquerque living room. The foot is a sign of forward movement, of taking steps along the path toward enlightenment. Milagros are anatomical tokens used as offerings in Latin cultures after a prayer for the healing of a specific part of the body has been answered, or to insure the safety of a journey.

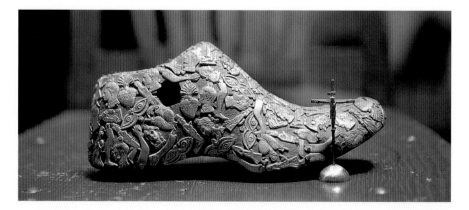

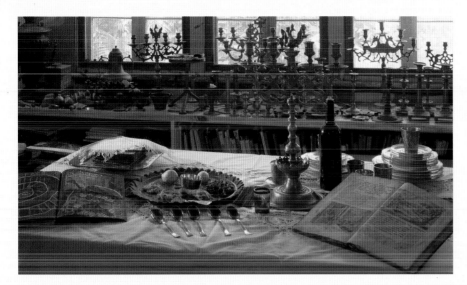

The Jewish holiday Passover celebrates the Jews' liberation from slavery in Egypt. A setting of ritual objects in preparation for a Passover seder includes, from left to right, a plate holding matzoh, the symbolic unleavened bread, covered with a ritual cloth; an artist's Haggadah, the book that relates the order of the Passover service, by Judith Levitin; the seder plate holding an egg representing fertility, parsley honoring the promise of the green earth, a shank bone representing the sacrifice of the lamb, choroses representing the mortar that held the bricks made and carried by the Hebrew slaves, and maror representing the bitterness of slavery. The 19th-century Haggadah at right contains the Hebrew prayers to be recited in the service over the holiday meal. Photograph by Steven Brooke.

Surrounding the "Devil's Hot Tub" by Tubby Brown are images, made from recycled tin cans, of some of the vices that get people in hot water. The "Devil with Snakes" features the snake as symbol of temptation. It is by Michel Sanvil, a Haitian Carnival mask maker who transposed the technique of molding wet sand to papier-mâché.

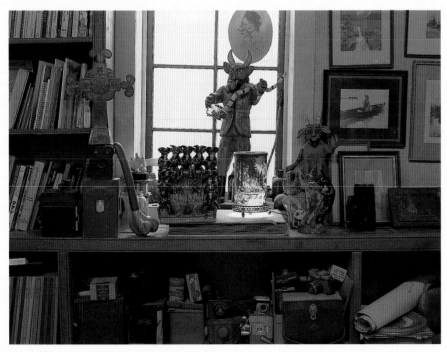

A tableau of devils is arranged in the study of Judy Booth and Jim Kraft. The carved Mexican devil figures are derived from Aztec culture which celebrates death as a stage in a constant cycle.

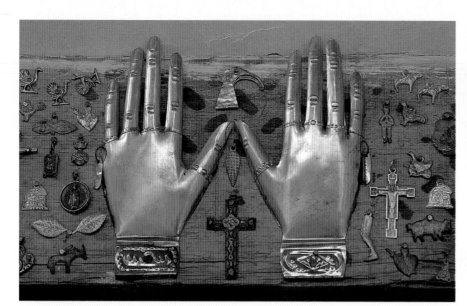

Hand symbols from various cultures:
Above: *A key ring holds a hemseh, the image of an open hand used in Sephardic Jews' homes to signify the direction of Jerusalem and to ward off the "evil eye." Lying next to it is a hand sculpture by Florida folk artist Mama Johnson, made from a stuffed surgical glove. The Asante or Ghanan fertility figure at right is known as Akua' ba.* **Left:** *Silver hand milagros from Mexico are displayed on the cross beam of a living room along with a collection of other medallions and milagros.*

A wealth of symbols, including a snake, gazing globe, and red rose, surround a prayer for the home in the kitchen of Terry and Jo Harvey Allen.

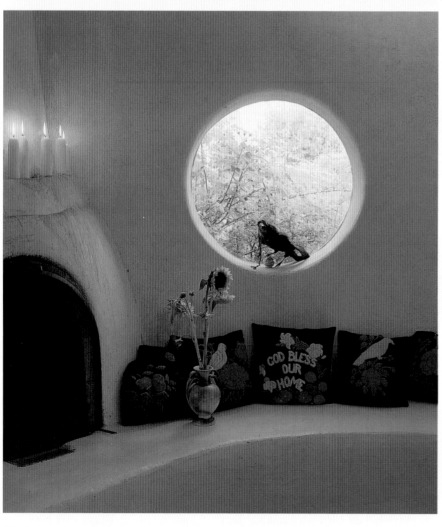

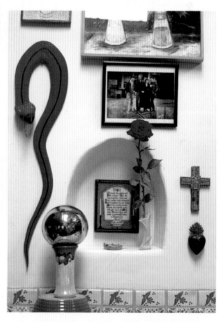

Birds, sunflowers, roses, and candles invest the Allens' casual living room with symbolic imagery. The crow is considered in Native American culture to be a messenger of new ideas and beginnings.

Madonna with a grouping of baby pictures may be as much—or more—an homage to motherhood as an obeisance to Catholicism. The use of prayer rugs over a marble floor can be as much a reminder of the need for meditation as a reflection of Islamic culture. A collection of antique brass candlesticks simply assembled in front of a stained-glass window creates a poetic homage to the mystical qualities of light.

Colors, like objects and architectural references, carry spiritual connotations. Their application can deepen the mood of a room or infuse a tableau with metaphysical content. Think of the purity of white, the majesty of papal purple and red, the radiance of gold. Like mystical imagery, color, imbued with distinct vibrational qualities, can extend the blessings of the divine and enlarge the power of the sanctuary.

Symbolism, more than any other aspect of design, determines a room's spiritual effect. It is the story behind the images, objects, color, and light that create a spiritual style. Without our understanding or attaching meaning to these elements, their power often remains purely decorative.

Floral symbols of affirmation transform a niche in the Allens' Santa Fe garden wall into a personal altar.

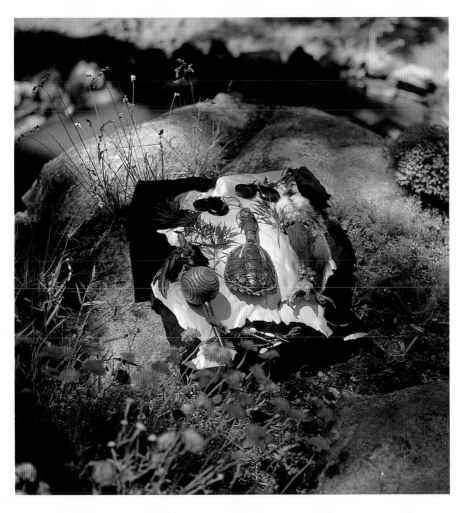

A medicine bundle, laid out in preparation for the performance of a ritual, includes a rattle for shamanic invocation, castanets as an homage to the owner's Spanish ancestors who were dancers, a turtle shell which in Native American cosmology is considered the animal bearer of the earth, and an eagle claw representing the bird which symbolizes soaring height and the luminosity of the sun.

GARDENS

WHERE THERE IS FORM, THERE IS NATURE. WHERE NATURE AND HUMANS INTERACT, THERE IS A GARDEN.

Machaelle Small Wright

THIS GARDEN IS, LITERALLY AND FIGURA-TIVELY, A PLACE TO STAND, AN ANGLE OF VISION . . . A RALLYING POINT FOR . . . PERSONAL VALUES AND A FOCUS FOR . . . CONCEPTION OF THE SELF.

Maynard Mack

For many cultures, the story of human life begins in a garden. From that first miracle of multiplication, the garden became a symbol of fertility and, in numerous traditions throughout history, an archetype of Paradise.

The contemporary gardener is parent, midwife, and witness to creation—from the planting of a seed through the acts of nurture, to the bearing of fruit and flower, and, with the culmination of a growing season, to death and the promise of renewal. In the garden, the life-giving tree, fruit, or flower is the reward for spiritual pursuit.

Many contemporary gardeners cultivate their gardens as a reflection of the inner landscape, its features used as metaphors for the spiritual life. A garden path, for example, can represent the spiritual path—never straight, and thus demanding awareness to take in the details of its every view. The garden canopy, whether a natural growth of leafy boughs or carefully tended arbor, can symbolize the shelter of the divine. Even garden ornaments, from gazing globes to sundials, and from artists' sculptures to traditional crèches, can be used to illustrate the gardener's reverence.

The enclosed garden, whether surrounded by hedges or circumscribed by a stand of trees, provides an ideal site for private ritual and meditation. Historically, enclosed gardens represented the feminine, protective principle (and in early religions, virginity). As the place where Nature is subdued, ordered, selected, and cloistered, it is also a symbol of consciousness (as opposed to the forest, which represents the unconscious).

Portals, gates, and garden walls can evoke a sense of spiritual drama. As backdrops for ritual and as sites for offerings, walls define the garden stage. As metaphors for the doors of heaven, portals and gates lead to the promise of paradise. Such a paradise was envisioned by the Mughal rulers of India as a garden where "angels, gentle beasts, bright birds, and glittering fish lived in perfect harmony among the sweetest of blooms."

The sound and sight of water in a garden can deeply enhance its tranquillity. Water lends prismatic and musical qualities where it trickles over rocks or spills down a fall. The stillness of a reflecting pond or pool is calming. The owner of the garden on the facing page considers its presence "critical to a sense of serenity."

Carol Anthony's meditation hut in her Santa Fe cloister is built of hay bales plastered with adobe. Flowers grow on the "living roof."

A spiral symbolizing Gaia, the Earth Mother, is the floor of the prayer sanctuary in my own garden. The design is made of broken coquina stone and mulch.

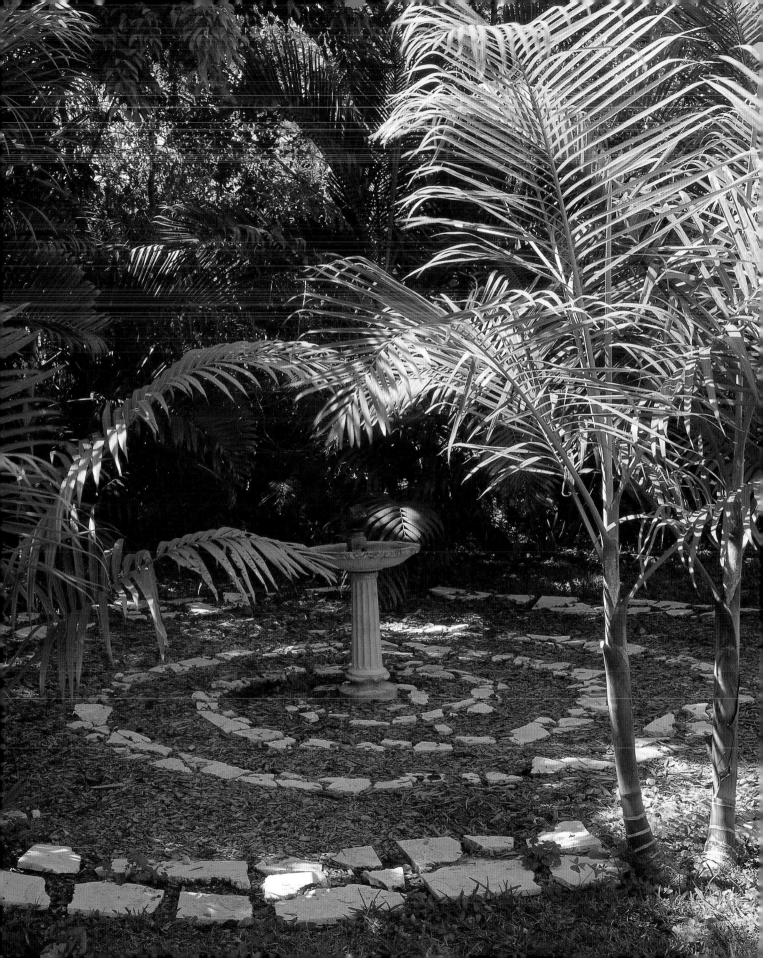

Many contemporary gardeners encourage serenity by planting fragrant vines and bushes such as jasmine, gardenia, and rose—their perfume alluding to the sweetly scented air of paradise. Precedents for this custom reach back as far as the early Romans, who cultivated grapevines to provide for libations and as a symbol of life and immortality, and roses for their fragrance and to signify eternal spring.

In contrast to the hedonistic pleasures of the Roman-style garden is the refined simplicity of the Oriental-style garden, where appreciation for the subtler beauties of form, texture, and tone are cultivated. In Japanese-style settings, the garden vocabulary revolves around such elements as stones and mosses and around such disciplines as bonsai and raking. Early Japanese gardens, actually known as "paradise gardens," were designed for the Buddhist deity Amida to celebrate a land of purity and goodness. Ancient Shinto religion taught that rocks are the abodes of the gods, and their

Garden portals represent the doors to paradise. A carved wooden threshold frames the entrance to a New Mexico garden. The keyhole-shaped entry to an ancient garden in India is supported by sculptural columns. Photographs by Peter Vitale.

"secret texts" spoke of auspicious and taboo placement of landscape elements. Miniature gardens of Taoists are considered earthly copies of paradise. Combinations of these more subtle approaches to garden design are seen today even in such fecund subtropical climates as southern California and Florida.

Some present-day gardeners seek to create images of paradise that combine this Oriental sense of order and control with a more Western sense of vast perspective. Such gardens hearken to those of 17th- and 18th-century Italy and France. These sweeping landscapes were designed with symmetrical plantings and axial layouts that took their cues more from architecture than from nature.

Those gardeners who favor a more "natural" looking yet still highly cultivated image of heaven often look to the English landscape gardens of the 18th and 19th centuries. With their framed perspectives, broad curvilinear lines, and placement of small garden pavilions, these glorious landscapes represented a picturesque journey to paradise, planned in harmony with, but distinct from, nature.

Garden walls such as these in India and Indonesia are used as sites for prayer offerings. Photographs by Robert Strell.

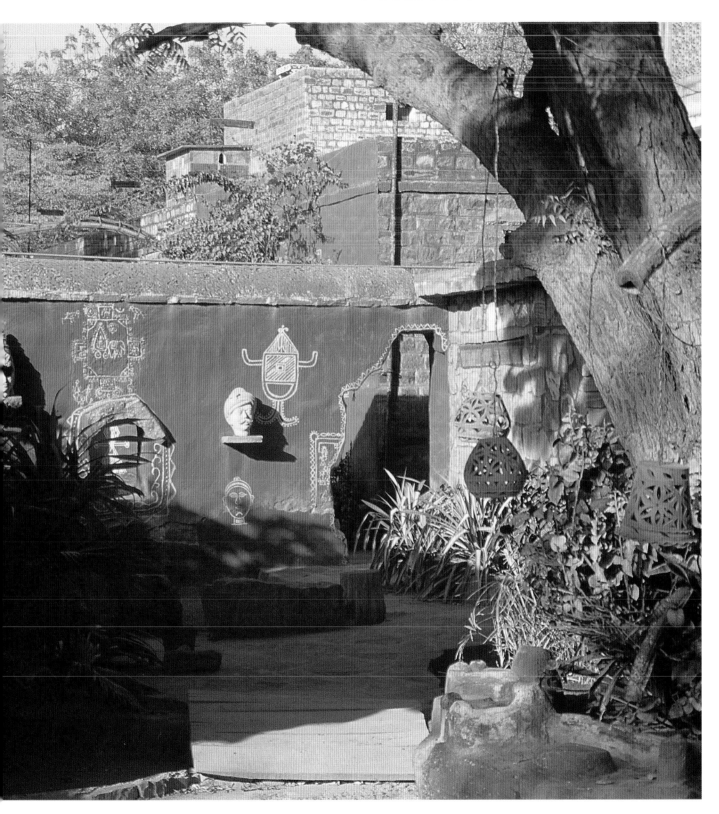

Flowers, like gardens, are enriched with spiritual meaning. The rose, for example, is emblematic of Venus, goddess of love, and signified to the ancients the attributes of passion, devotion, and secrecy. For the early Christians the rose became a sign of pure love and sacrifice, just as the lily became the symbol of purity.

The art historian Barbara Novak perhaps best describes the symbolic value of flowers: "The flower is the epitome of the life-spark, vitality's archaic proof. Life, death, resurrection, mortality, immortality, growth—all are implied by the flower, whose constant presence on a planet filled with living things has invited culture after culture to deposit this rich palimpsest of references."

The portal to Sharon Ely's "Garden of Love" is symbolically announced by a gazing globe and sunflower.

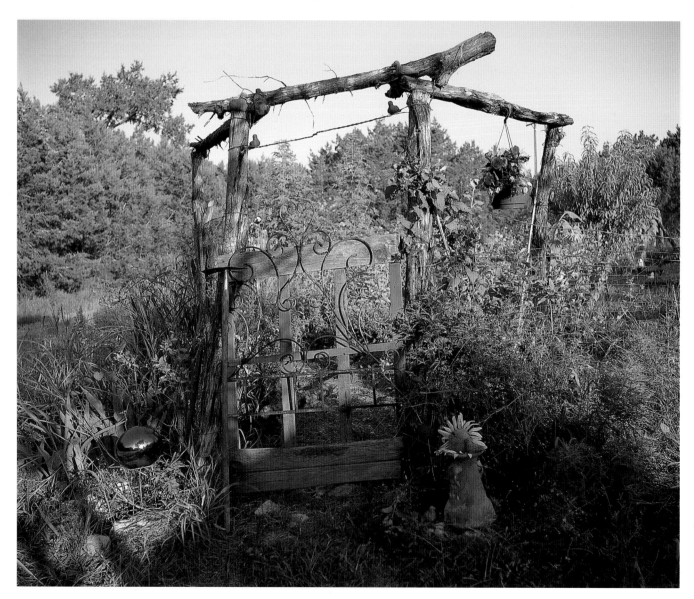

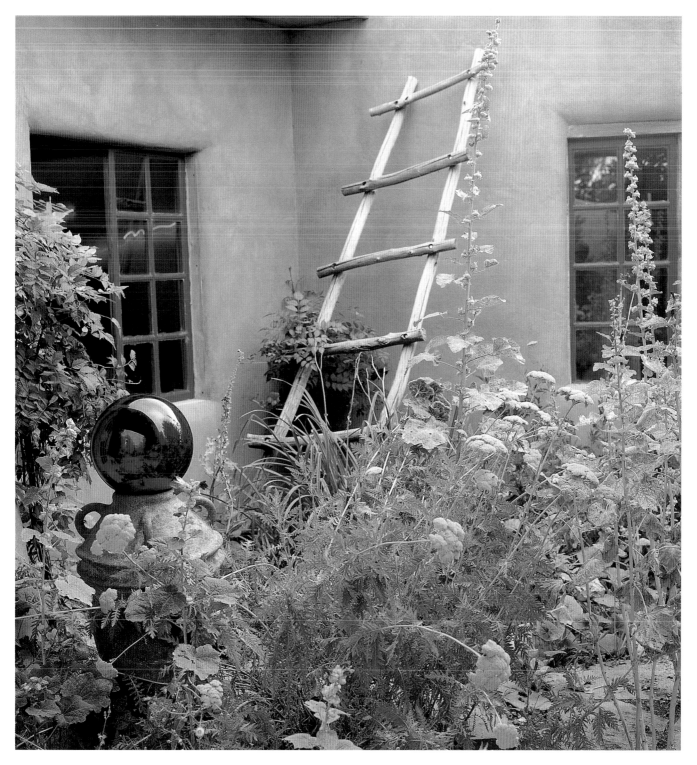

A gazing globe set among desert flowers adds a celestial blue accent to Terry and Jo Harvey Allen's New Mexico garden.

In a Bird Goddess garden, the Mother God in her guise as Bird Mother watches over her world where she nests in the tree of life, feeds her offspring from the seeds of the earth, and lays her eggs of regeneration. The sculptural panel, entitled Return, is by Judith Hoch.

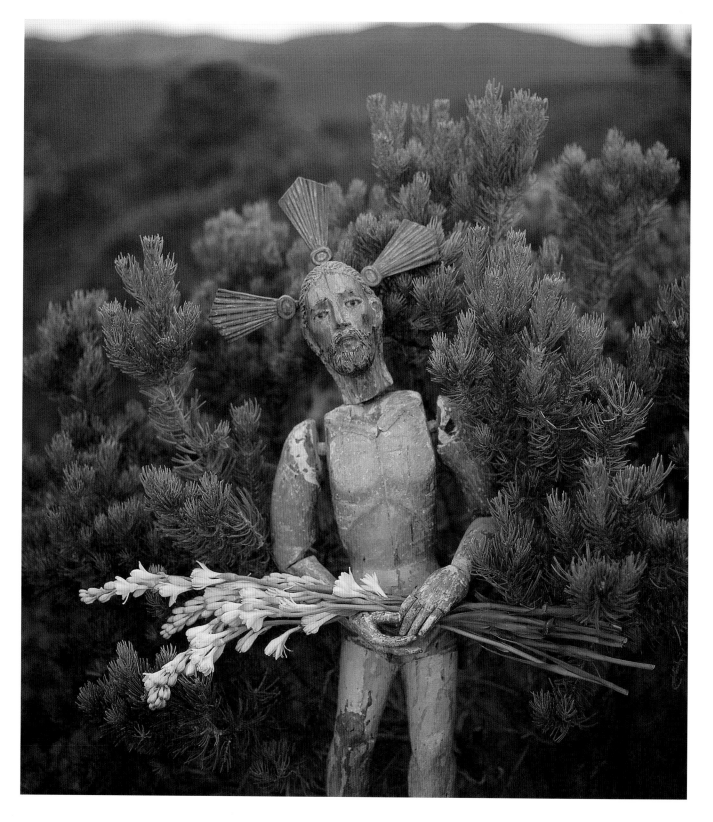

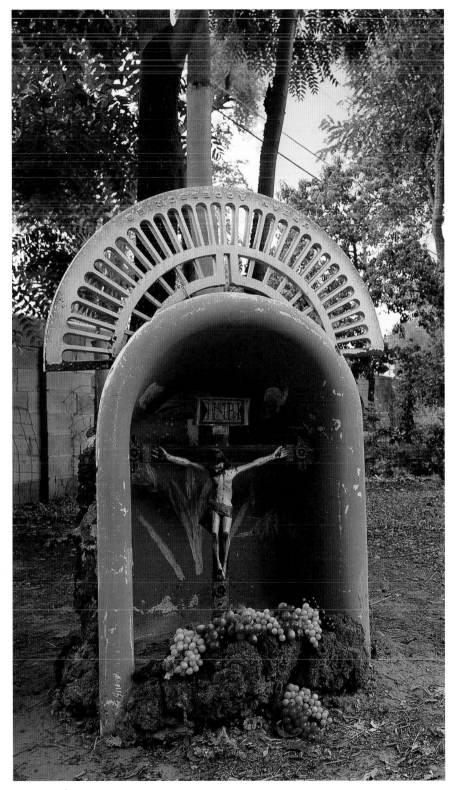

In preparation for an Easter celebration, a carved wooden Christ figure is set against a dramatic mountain backdrop on the terrace of a New Mexico home.

The Albuquerque garden of Jim Kraft and Judy Booth is made magical by painted tree trunks and a crèche constructed from a bathtub and containing a 19th-century wooden crucifix.

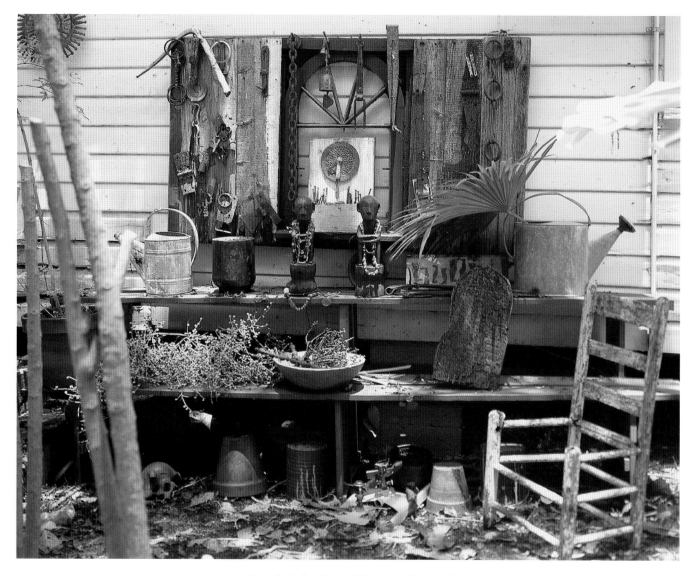

Outside Richard Warholic's Everglades City house is an assemblage of artifacts that the artist uses in his art work along with ritual items he surrounds himself with for spiritual inspiration. At center are two rice gods from Bahol with beads, and above them, one of Warholic's collages. The colonial locks from Brazil, at left, form a Maltese cross when grouped together.

Jim Kraft and Judy Booth's sculpture garden is entitled Black Choir. Constructed of stones given to them by a friend, it evokes for the couple a sense of "harmonious, gospel joy." The offerings laid atop the stones are added as they are found.

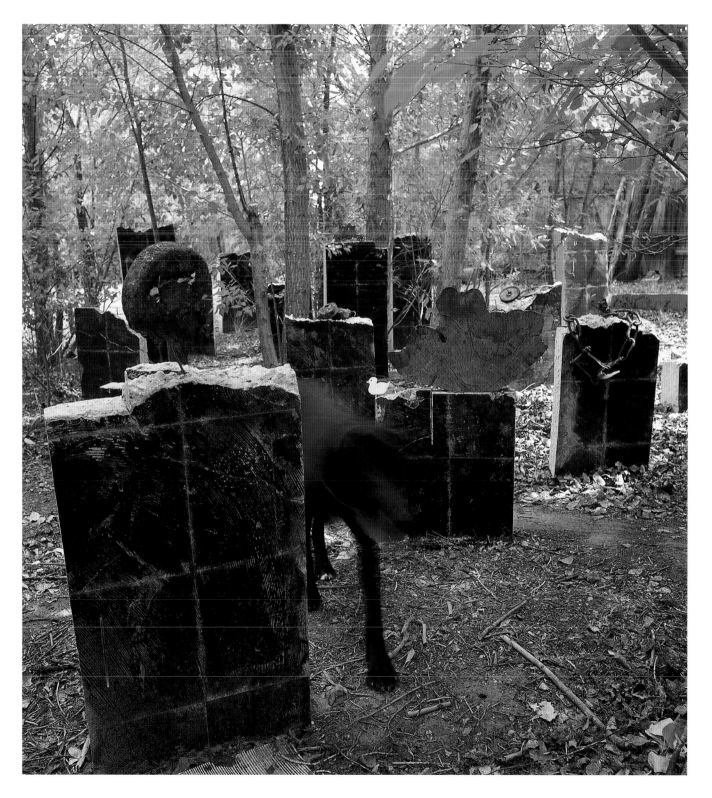

GODDESS GARDENS

Whether cultivated in a womb-like cloister or an open meadow, in a field of flowers or fenced backyard, the goddess garden pays reverence to the Great Goddess. Two sculptural panels by Judith Hoch transform my subtropical retreat in Miami into an exotic narration of goddess mythology. *Minoan Rites,* installed at poolside, celebrates the spiritual traditions of the matriarchal civilizations of Crete and the Cyclades at around 1500 B.C. Minoan Crete is believed to have been a peaceful, playful culture centered on honoring the Great Goddess through dance, music, art, ritual, prayer, and sexuality. As represented in Minoan and Mycenaean iconography, its imagery of dolphins, birds, octopi, flowers, and bees focused on the beauty of nature.

The other panel, *Warrior Mother,* above, installed in a glade setting at the front of my property, calls for the preservation of nature. The figure on the left is Artemis, Greek mythology's protector of animals. The figure on the right is based on a Greek Neolithic sculpture of the Snake Goddess embracing a young animal. The middle panel is filled with images of magical dogs who hunt with Artemis at night and help her to vanquish evil spirits.

Inspired totally by personal intuition, the female guardians created by Beverly Magennis, opposite, project an entirely different sense of spiritual character. These inscrutable figures carry fruit on their heads like Latin glamour queens and observe the life of the artist's Albuquerque ceramic garden with the serene amusement of Black Madonnas. Comical, conical, colorful, and watchful, they and their animal counterparts are made of high fired black stoneware that is stained rather than glazed.

ROOMS AND SHRINES

In Hindu households, the doors of the shrines are opened for family worship so the devotees can see the figure of the god inside and the gods can see the worshipers. Photograph by Robert Strell.

Antique Buddhist offering bowls from central Burma and Paghan are grouped in the Albuquerque home of architect Robert Strell. The bowls were originally brought to monasteries and put on altars bearing food and flowers.

In many religions, shrines are regarded as points where the divine world touches the secular world. In others they are sites imbued with metaphysical power derived from a significant event or presence. Whatever the tradition, a shrine is a place where worshipers can immerse themselves in spiritual practice.

That "measure of yourself" which Louis Kahn invokes reveals itself in the siting, architecture, and composition of a room or shrine. Regardless of whether the site is carefully planned or evolves without great deliberation, these elements can amplify its power and quality of spiritual expression.

A room filled with sunlight—or moonlight—invites an altogether different experience than one closed to the elements, but suffused, perhaps, with candlelight. A circular room or one incorporating spiral shapes promotes a sense of movement, of dance. A room of soaring proportions draws the eye and spirit heavenward, while one of intimate scale fosters introspection. A beautifully proportioned room nurtures a sense of harmony; a vividly colorful one excites the spirit; an exquisitely austere room promotes serenity.

Spiritual power also can be invoked through presentation of the four natural elements. The movie director Laura Esquivel speaks of their effect in her own home: "I set out water in the north; incense to recognize the air in the east; flowers for the earth in the south; a candle for light from the west. It helps me keep perspective."

The Chinese practice known as Feng Shui is a form of geographical divination that addresses the balancing of the *ch'i*—or vital energy—in a building, monument, or room through use of the natural elements. According to Feng Shui, certain places have clear access to the beneficent *ch'i* while others are devoid of its power. The magical qualities derived from links with the environment can be called forth or enhanced by the incorporation of the natural elements. It is the combination of the Elemental—earth, air, water, and fire—and the Human, in the form of conscious design and personal content, that evokes divine presence.

The quiet of Valerie von Sobel's meditation room is tinged only with the subtlest of sensations—the fragrance of balsa wood, cedar wood, and burning incense, and the

The meditation room of Los Angeles designer Valerie von Sobel replicates Japanese design tradition. The tokonoma is constructed of tokobashira, a Japanese wood grown specifically for use in altars. Aromatic balsa and cedar were used for the steps. Photograph by Mary Nichols.

soft sounds of koto music and water trickling in the garden outside. Created after a time of excruciating tragedy, the room's pristine simplicity perfectly addresses Mrs. von Sobel's need for serenity, for an environment that soothes her throughout her search "for a road map for survival."

Originally the bedroom of Mrs. von Sobel's teenage son, the room was once covered with posters of rock stars and other souvenirs of raucous adolescence. For the eighteen months during which mother and son fought his inoperable brain tumor, it was the private haven in which they "traveled together to his death," where they learned together that "there was a life before and will be a life after."

The tragedy forced Mrs. von Sobel to discover her own reservoir of inner strength. "Before, I had always collapsed into other people's kindness; now I can stand staunchly alone." Her husband, unable to cope with the pain of their son's illness, killed himself. Her own mother died shortly after her son. Personal effects of all three loved ones rest on the altar.

The design of the room is authentically Japanese, its stark purity a departure from the lavish style of interiors for which Valerie von Sobel is professionally known. "Previously, I never had any interest at all in modernism or simplicity. My tastes ran to grand, sweeping interiors, elaborate designs filled with rich fabrics."

In her meditation room she features a tokonoma, an aesthetic shrine on which an ikebana—ritual flower arrangement—and a calligraphic scroll are displayed. Traditionally these art forms are the work of the homeowner and are regarded as expressions of Zen Buddhist philosophy. Compelled, but without understanding why, she added a step, later realizing that she had wanted a separation between the room and the altar. The altar retains the spiritual presence of her departed family;

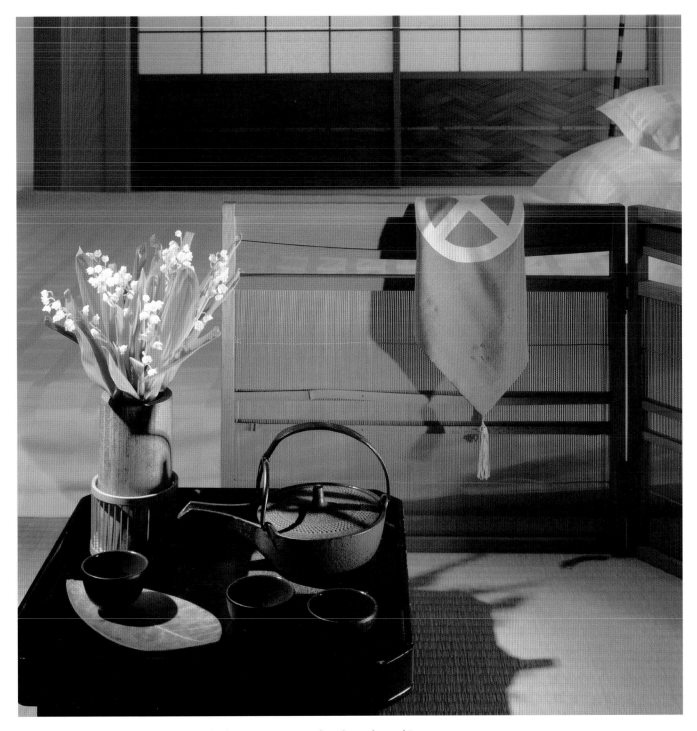

The striped pole is a Tibetan begging stick. The tiny screen is used in the traditional Japanese tea ceremony. The tasseled cloth is a customary part of gift giving in Japanese high society. It is used to cover a gift when it is given or sent and is returned when the gift is received. Photograph by Mary Nichols.

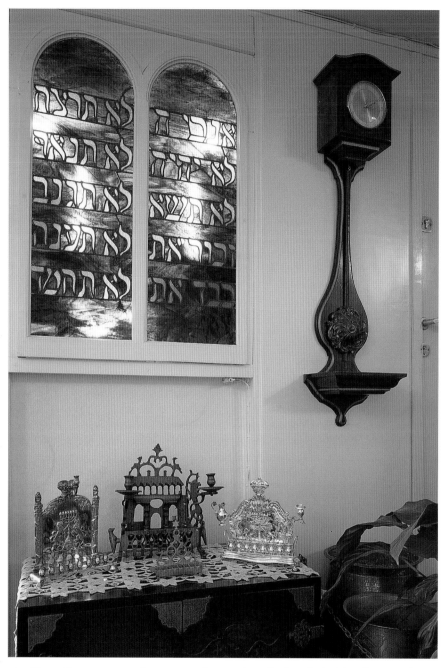

A tableau of antique menorahs is arranged beneath a stained-glass window in a Jerusalem house in the Old City. The Hebrew text on the window is the Ten Commandments. Photograph by Steven Brooke.

the step represents a division between her former life and the present.

Architect Robert Strell's quest for inspiration has taken the form of traveling the world in search of "pictures I will never tire of." He has visited sacred sites on nearly every continent, and in each instance comes away with "another piece of my picture of paradise." Along with the images, he returns with artifacts that carry their spirit and beauty. Their compositions in his Albuquerque house become shrines to their sources of inspiration.

An eloquent grouping of antique lacquered Buddhist offering bowls (page 61) is the result of a trip to Indonesia. Made from coconut, wood, and woven palm, the bowls are lacquered to an exquisite smoothness and subtly inscribed inside. Some resemble lotus flowers in shape and others are formed like stupas. This symbolism, added to their dramatic orange, red, and black colorations, enhances the meaning and visual power of the shrine. "As an architect, I'm accustomed to devising means of leading the eye," he says. "In my own home, the visual destination must be deeply meaningful."

An American couple living in the Jewish Quarter of the Old City of Jerusalem installed stained-glass panels inscribed with the Ten Commandments in place of a conventional window (at left). Their presence provides the couple with a continual reminder of how the light of their Old Testament faith shines upon their lives and makes their home a religious as well as personal sanctuary.

Tirza Moussaieff's shrine to her grandfather is composed of his portrait, other family

photographs, and artifacts from his home-land. It evolved out of her journey—both personal and geographical—to discover her spiritual roots. In 1989, at the beginning of Perestroika, she was able to travel through the Soviet Union to Bukhara, where she discovered a culture vibrant with color. She fell in love with both the place and its material arts, especially the textiles and porcelains. She also learned a great deal about her heritage.

In 1890, Shlomo Moussaieff, Tirza's grandfather, made a long-dreamed-of pilgrimage from Bukhara to Jerusalem. In his caravan of 100 camels he carried crates filled with the finest examples of Bukharan arts and crafts. The journey took nine months, and upon his arrival, Shlomo Moussaieff became the spiritual leader of the Bukharan people in Palestine.

The Bukharan quarter in Jerusalem, which Shlomo and his community constructed, combined the most beautiful elements of Eastern and Western architecture. Shlomo's own palatial house had seven large rooms and a "museum" where he displayed handmade Bukharan carpets, quilts, ictus, and jewelry as well as clothing made for the Emir of Bukhara.

Shlomo Moussaieff died in 1922. Nothing is left today of the museum except his unique collection of rare books and manuscripts, most of them dealing with the Kabbalah, the Jewish mystical text. It is the only library of its kind in the world.

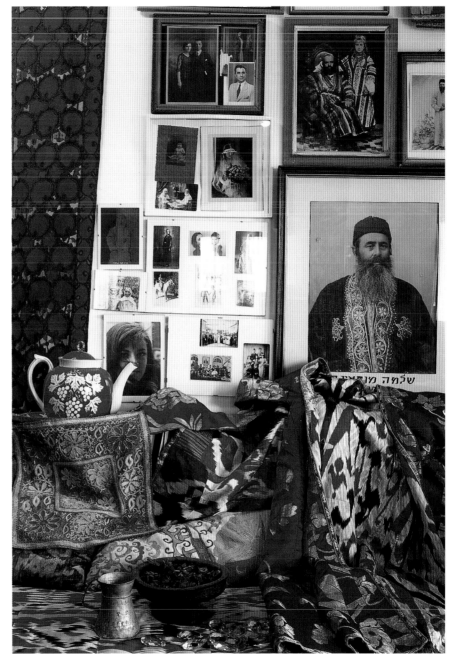

Tirza Moussaieff's shrine to her ancestors centers on the family patriarch—her grandfather—whose image is surrounded by others of her family. Photograph by Steven Brooke.

Carol Anthony positioned her shrine to be the first image encountered upon entering her house and the visual signature of her spiritual domain. Framed by a carved

wood portal from Rajasthan, this small altar room features a large monotype that has been variously interpreted to be a representation of the goddess Gaia, a tulip (Islamic symbol of regeneration), and benediction goblet. The art work's elusive quality dramatically contrasts with the assertive character of the steel altar table and heavily hewn candle holder below it. Illumination for this starkly commanding setting comes from sunlight, which pours down through a skylight. This single source of radiance mirrors the simple beams of light that illuminate the rooms in Anthony's paintings.

Her rooms are inner sancta in which she celebrates solitude, places "where you can be heard without speaking." She considers the rooms in her art as well as the rooms in her house to be "footnotes to a whole philosophy." One luminous oil crayon image on panel, entitled *Manger Room,* depicts a Last Supper table without Christ and his disciples. The piece is about knowing "that you can eat alone and still be heard and loved."

On the wall behind the "real life" table where she eats hangs a sensuously abstract painting by her identical twin sister, the artist Elaine Anthony. Next to it hangs an altar-piece dedicated to Elaine, who died in 1995. Together the two works of art comprise "a message from a larger conversation about life, death, and the transcendence of spirit."

A "memorial wall" in Carol Anthony's dining room includes an oil on panel work by her twin sister Elaine Anthony as well as an altar to her. The miniature hay bale and other offerings are aspects of the New Mexico landscape and of Carol Anthony's house that her sister loved.

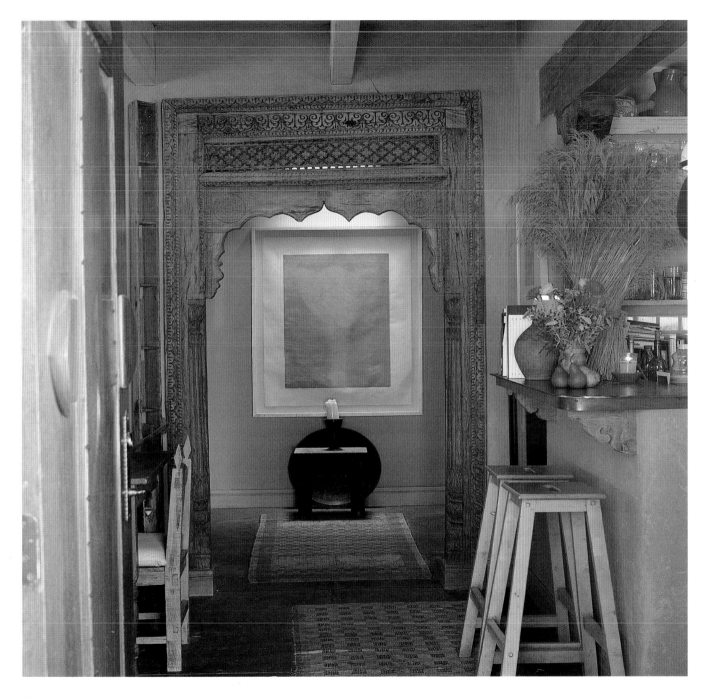

The altar room in Carol Anthony's New Mexico house is composed with a monotype by Marcia Weese, a steel table by Larry Swann with chiaroscuric finish, and a carved ceremonial tray. The shape of the candle holder echoes the shadowy form in the monotype.

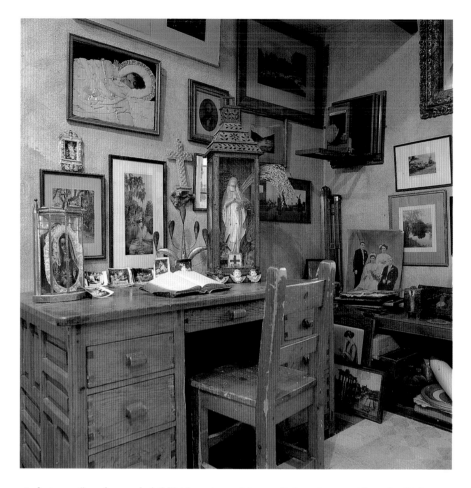

A shrine to "mother and child" (above) combines religious icons with early-20th-century photographs. Images of virgins, brides, infants, and ancestors are composed on the desk and walls of a study where their gentle gazes fill the room with an aura of innocence. The tender effect of the composition is made poignant by the inclusion of a series of funerary photographs of Mexican infants.

Beamed ceilings and abundant candlelight give shrines in two distinct parts of the world a similar sense of Old World mysticism. The altar room in an Irish castle (page 70) was created for ritual worship of the goddess Isis. Primitive surfaces, in addition to the crude beams, include stone walls and age-worn brick floors and columns. A family chapel outside Santa Fe (page 72) was made from plastered adobe mud walls and ceilings crafted from *vigas,* large beams, in between which *latillas* or small herringbone wood pieces are patterned.

The room is the work of *santero*—a maker of sacred images—Ramón Jóse López, an acclaimed New Mexico artist who took up the artistic and spiritual traditions of his Spanish heritage, passed down to him through his *santero* grandfather. López is a winner of the National Endowment for the Arts' National Heritage Fellowship, its most prestigious honor in folk and traditional arts.

López describes the chapel, in which he often sleeps, as possessed of a healing quality: "When you sleep here, you awaken to images of saints all around you." He made the six-panel altar screen, or reredos, according to tradition, with an adz and painted it with natural pigments made from plants, minerals, and insects. He designed the bed not only to sleep on, but for childbirth, hence the image at the foot (on the right) of San Ramón Nonato, the patron saint of midwives. Its mattresses are made from the wool of eighteen buffalo.

The polychrome retablo, or two-dimensional image of a saint, to the right of the bed is painted on a wood panel. To the left of the bed is a cross that López painted on pine, glazed with mica, and encased in sterling silver. His son Bo, at age eleven, made the large cross standing against the wall, which he carried in a Good Friday procession.

A still-to-be-remodeled bedroom (page 73) was improvised as a shrine to two goddesses of sensuality—the mythological Aphrodite and the Yoruba deity Ochun. A carved and painted wood panel by artist Judith Hoch depicts Aphrodite, who was revered as the creator of arts and letters, governing the natural cycles of life and death. Aphrodite's other celebrated gift was that of sexual love.

The Yoruba river deity Ochun is represented by the color orange of the bedcovering and by the diaphanous gold fabric that spills, like a river, from the bed to the floor. Ochun is also personified, by Cuban Catholics, in the form of a Madonna known as La Caridad del Cobre, or Our Lady of Charity. She is seen in the form of a bronze medallion at the foot of the bed.

After seeing so many spiritual installations in the course of producing this book, Matthew Fuller suggested transforming my kitchen in Miami into my own shrine to creativity. The room badly needed remodeling because of its black laminate surfaces and ugly, outdated appliances. We mounted my art works on the room's cabinets and walls. The black laminate made a perfect background, especially for the gilded frame assemblages. My collection of frame fragments took on practical application as door and drawer pulls. Since I don't cook, I was happy to see the appliances disappear into the baroque busyness of the scene.

A Madonna shrine in Judy Booth and Jim Kraft's study is composed of images that pay homage to the holy notion of mother and child.

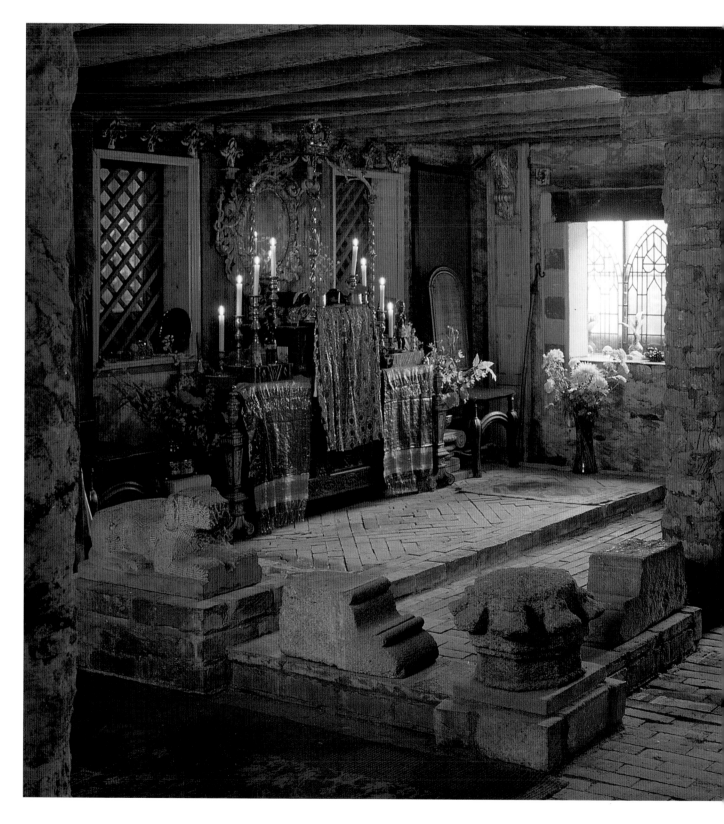

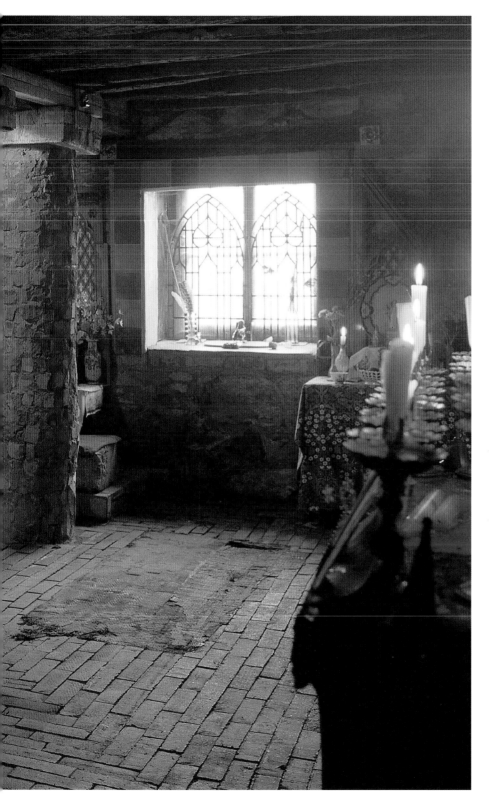

A shrine to Isis is the ritual focus of a religion created by a brother and sister who live in this Irish castle where fellow worshipers join them in communion. Photograph by Peter Aprahamian.

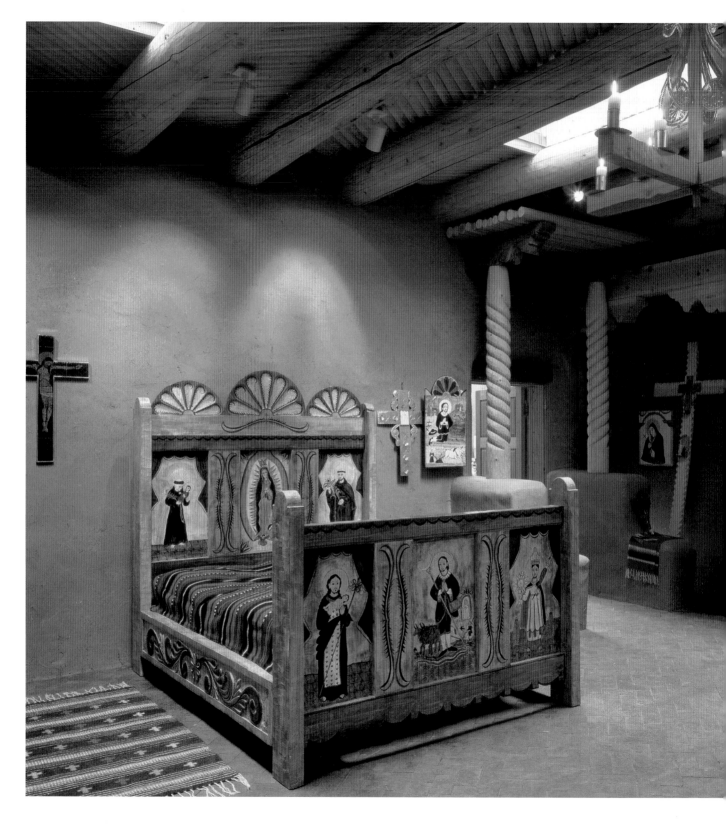

Aphrodite is invoked into a bedroom setting through the use of vivid color in fabrics and flowers and through her image, as interpreted in a screen by Judith Hoch.

The bed, altar screen, and images of saints in this bedroom chapel were created by Ramón José López. His art work follows the traditions of the original santeros, who first came to North America from Spain 400 years ago and produced images of the saints for Catholic worshipers and their churches. Photograph by Robert Reck.

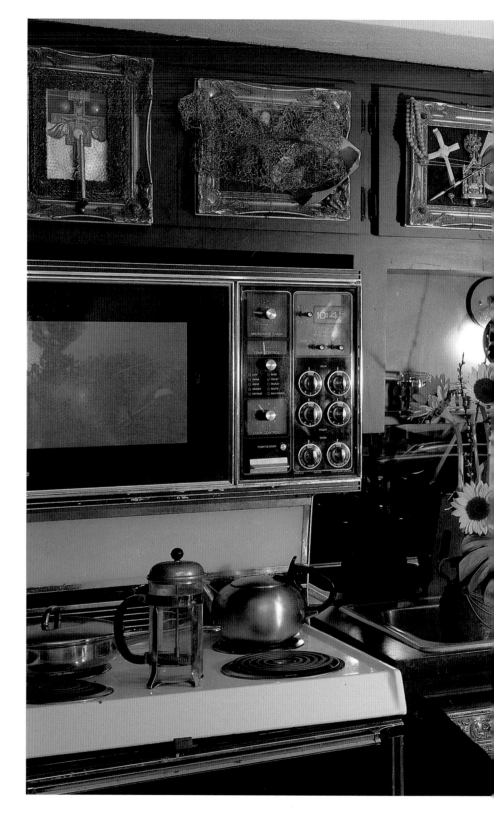

The dark, depressing kitchen of my Miami house had been awaiting remodeling since I moved in. With the installation of my art work, it became vibrant. The images all hold deep meaning for me, and their strong presence encourages me to reflect on them daily. Photograph by Steven Brooke.

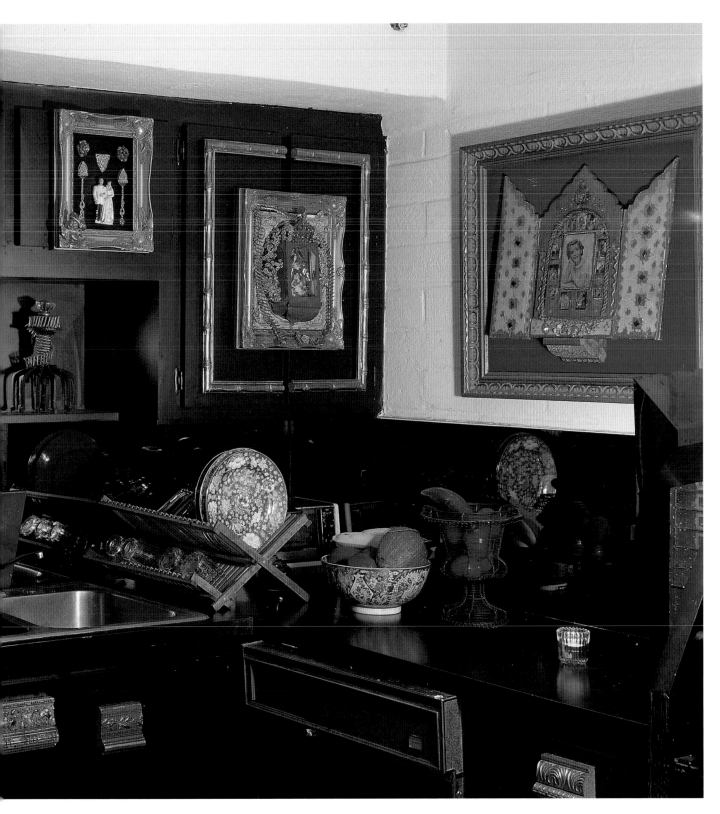

A Personal Shrine to Creativity

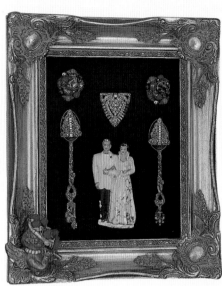

My own creative work is deeply rooted in religious art and spiritual expression. The style of imagery draws heavily from Christian iconography, medieval manuscript illumination, and Catholic folk art. The compositions often recall the Byzantine in their *horror vacui,* animation, and their delight in violation of the frame. I use blood to allude to the goddess cultures; fragments and ceramic shards refer to the tesserae of Roman and Byzantine mosaics; hair and bones suggest Christian reliquaries. I also incorporate jeweled encrustations of the Carolingians, the roses of Renaissance painting, the nails of the Spanish Gothic, and the abundant vessels of Buddhist and Afro-Caribbean obeisance.

The frame is a significant feature of my art. I tend to work from the outside in, creating an environment that, in the end, appears to be an object of worship. In my more Byzantine pieces, layers of frame—or the architecture of the image—becomes indistinguishable from the "subject."

I have always been attracted to rusted and patinated finishes as much as to gilt. The binding of worn and aged with the rich and gleaming creates a look of burnished elegance, an effect of opulent decay.

My assemblages and sculptures express my passion for ornament. I enjoy applying decorative embellishments to solemn subjects, thereby violating their expected gravity. Sometimes I do the reverse—creating a whimsical context for a reverent subject. The unanticipated contradictions often cause the viewer to reflect on his or her acquired expectations of the image.

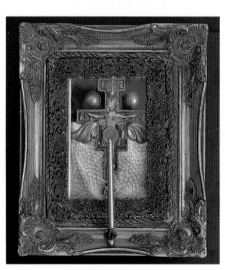

Top: *Heterosexual Fulfaggotry*
Above: *Alignment in Fulfaggotry*

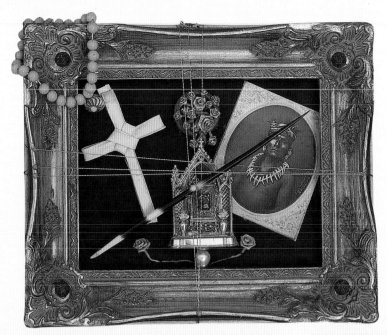

The Way West is Through the Heart

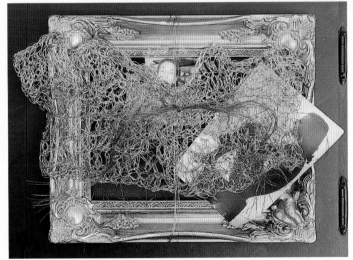

Aunt Barbara Through the Veil

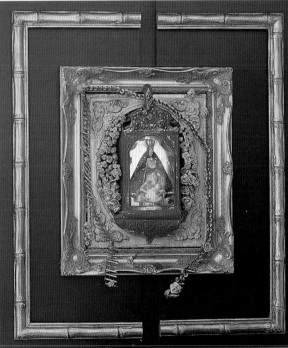

Blessed Mother / Mother and Child

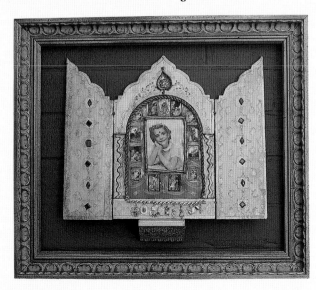

Who She Was / Who She Would Be

ALTARS

THE CONSTELLATIONS, ANIMALS AND PLANTS, STONE AND THE LANDSCAPE WERE THE TUTORS OF EARLY HUMANS.

J.E. Cirlot

NOTHING IS TOO BEAUTIFUL FOR THE ENLIGHTENED ONE.

Buddhist Saying

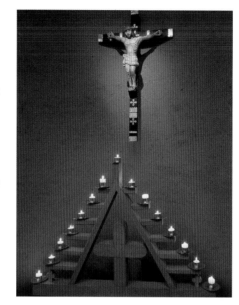

The New Mexican artist Ramón José López created an altar with a pyramid of candle-light. Photograph by Robert Reck.

An unfinished altar by cave digger Ra Paulette is carved into the walls of a "guest cave" in New Mexico. The clay lines indicate where the dunes have folded into the substratum. Bits of fossilized obsidian are set into the niche.

Whether created as the visual focus of a home or cloistered in a private corner, the altar commands and expresses energy. While less elaborate than a shrine, which usually denotes a place of personal or historic commemoration, it is still a site of power. It is a place where eyes are drawn, where prayers are focused, where offerings are made, and from where the utterances of the supplicant are taken heavenward.

The earliest altars were likely considered by their makers as access routes through which spirits could enter and leave the world. Used for sacrifice, consecration, and prayer, they were erected at sites where the presence of divinity was indicated by a natural formation—at a spring, under a shade tree, or on an unusual rock formation. Later they were created wherever the mystical manifestation of a deity appeared or wherever the aid of a deity was invoked. Now altars are also found in temples, public buildings, marketplaces, and courtyards. They have always been the devotional heart of the spiritual home.

The altar is a powerful tool for rooting life in meaning—for visualizing hopes and for synthesizing that which is dearest, most poignant, and most powerful. Its purpose is to change consciousness, to elevate the supplicant's thoughts and feelings. To make an altar, to worship before an altar, is to transform one's own world. Like the continually unfolding experience of life, the making of an altar is a continual process—its elements added, subtracted, or modified according to season, occasion, or life event. Its meaning can reflect everything from the most traditional of values to the most immediate of aspirations, just as it can be composed according to a religious formula or personal inspiration.

The altar entitled *Honor the Bleeding Woman: The Cup of Guidance* (page 84) features an icon I designed with an image used in the Wise Woman tradition of healing. This tradition teaches that menstrual blood and birthing blood are holy, powerful, and healing. Reflection on the icon assists in experiencing menstruation as a time of height-

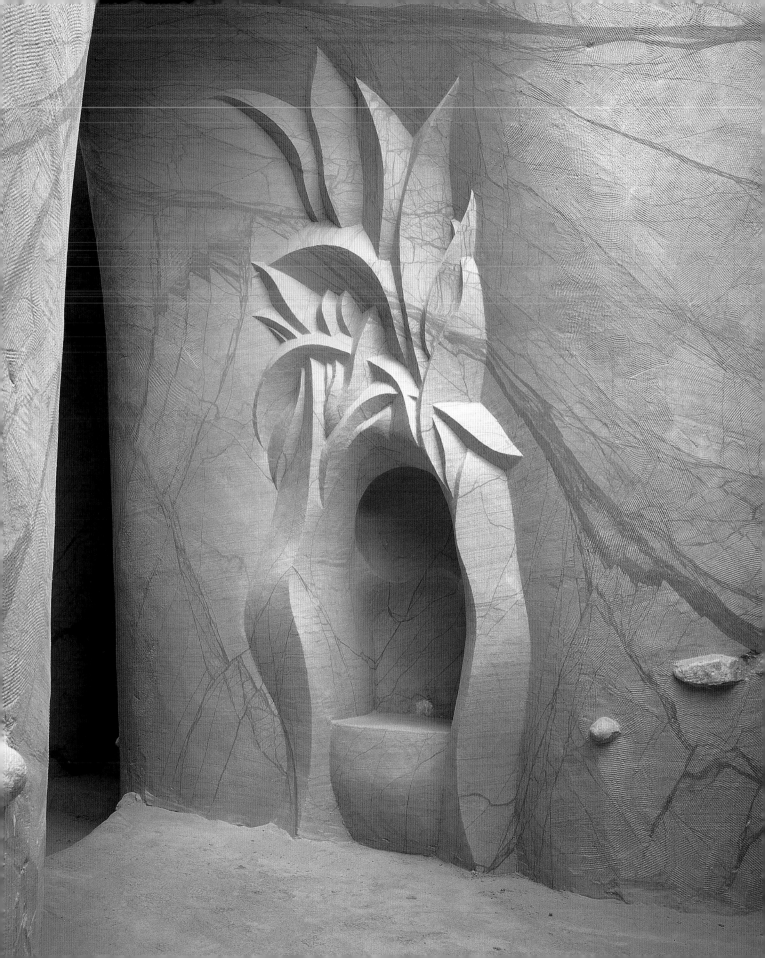

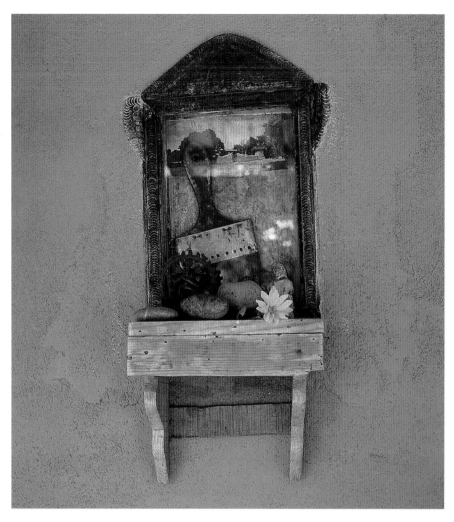

Two altars by Carol Anthony are tributes to those who "own the scars of age and experience" and to the New Mexico landscape and the act of painting it inspires. Casita Pear, 1993 *is oil crayon on gessoed panel with wood and stones.*

ened intuition and spiritual receptivity. Both highly personal in meaning and ornamental in its jewel-like design, the icon is meant to evoke a deeply universal female presence.

Purely abstract, in contrast, is the underground altar carved into the walls of a home dug by Ra Paulette out of the side of a hill in New Mexico. The malleable stone—"soft enough to dig by hand and hard enough to hold its shape"—is a geological product of the Ojo Caliente formation of 300,000-to-400,000-year-old sand dunes. Paulette became a cave builder out of the excitement and wonder of "burrowing into 'The Mama' and exulting in her insides."

The cave is a living sculpture, a "space you must walk through to see." The altar, a sculpture within the sculpture, represents, in its incomplete state, "the unformed place inside the artist from which creativity flows." Pregnant with the unmaterialized future, it is a reminder of the next stage, of new life and renewed energy.

A similar homage is expressed in Carol Anthony's altar entitled *Casita Pear,* whose image represents "ripe woman." The painting, weathered by exposure to the elements, is a celebration of the stage of life when "a woman can own her scars and accept the beauty of knowing what she's good at and what she's not." The two flat stones come from the Aegean island of Samos where Anthony and a group of women friends gather for retreats. She mounted them beneath the image to represent her sister Elaine and herself as "together and individual."

Death calls for some of the strongest and most effective altars. The death of Carol Anthony's sister was the transformational event that compelled her to create the memorial altar on page 83. A highly charged site, this altar enables the artist to "speak directly to her sister's spirit, to commune with her as if she were present." The memorial celebrates her sister's personal generosity and her love for Carol's house.

The presence of altars in this house is as intrinsic to its design and character as acts of reverence are to Carol Anthony's personal life. The altar at right was architecturally integrated into the adobe plastered wall of a cloister that surrounds a sanctuary garden. An homage to the act of painting and the landscape that inspires it, the altar literally and metaphorically draws together art and nature.

A garden altar (page 91), casual in its setting, stark in its simplicity, and powerful in its message, testifies to an artist's determination to make peace with disorder. Vines begin to grow up and through it, leaves fall and decompose around it. Guests walk past it. The artist works next to it, tending to the patina of a piece of furniture he is "weathering."

"This setting cuts you off completely," the artist says. "Once you enter those gates, you're in a private world, a sanctuary. The elements warn those who enter not to enter unless you're interested in wildness."

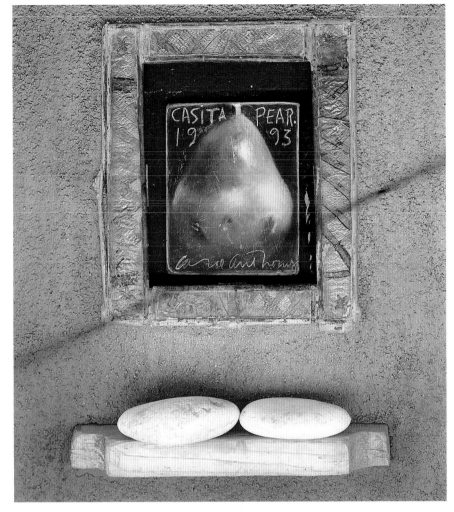

As the indestructible horse signifies, "This sanctuary is about not fighting nature."

At the opposite extreme is the formal composition of Haitian *drapos* arranged in the dining room (page 87). Their symmetry and exuberant coloration combine to create an altar of commanding visual focus. The symmetry reiterates the simplicity and balance of the cruciform shape, while the banners' vibrant sequined and beaded imagery beguiles the eye. The central figure in the altar is the Madonna of compassion who calls forth healing. The sword in her heart unites her in pain with the sufferer, while her composure and divinity promise relief from affliction.

The character and expressive power of an altar can be enhanced—and even determined—by its location. A centrally displayed altar in a household library (page 88) is celebratory in nature, meant to be enjoyed by all who enter the house. It is positioned in front of shelves of books that have served as sources of knowledge and understanding to the homeowners. The abundant lighting—from candles atop the

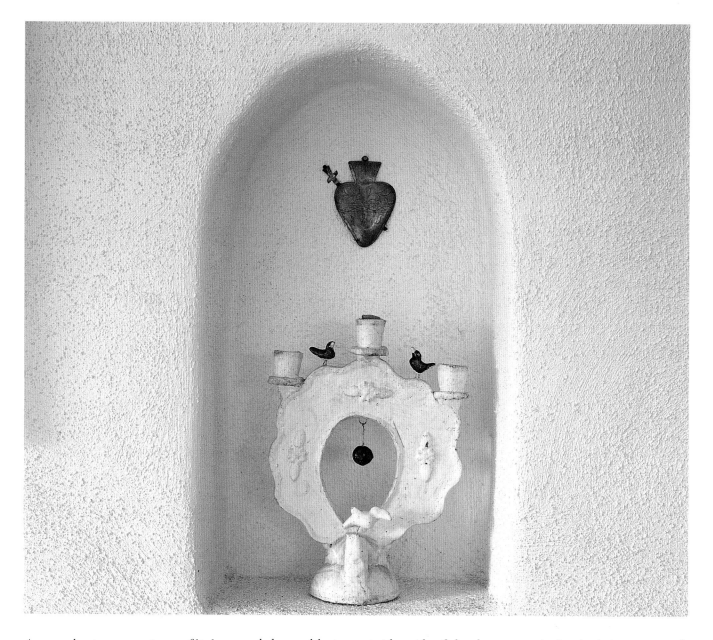

A prayer altar incorporates images of birds and the heart in a composition of austere sweetness.

shelves and lanterns at either side of the altar—extends the altar's joyous warmth throughout the household.

Completely private, on the other hand, is the effect of an altar set in a living room alcove (page 86). This architectural remove, evocative of a private chapel in a cathedral, intensifies the reverential focus on its traditional Catholic imagery. The intimacy of the enclosure, which is enhanced by overhead spotlighting, personalizes the act of worship.

Altogether different in character is a printmaker's studio (page 89) where an homage to the inspiring effects of color has been created by the placement of a bright plaster Madonna in the midst of shelves of ink cans. The Madonna's red and gold penumbra radiates throughout the workplace.

In an equally informal site, I combined humble materials to form an artist's altar to the Yoruba deity Ogun (page 91). Ruler of warfare and human labor, he is represented by iron in the form of nails, work tools, weapons, and the iron caldron. I arranged the altar on a table in the homeowner's favorite workspace, a breezy front porch. I used trays of iron nails, arranged more like a jewel box than a tool box, along with traditional artifacts, such as the caldron, to form the lyrically symbolic composition.

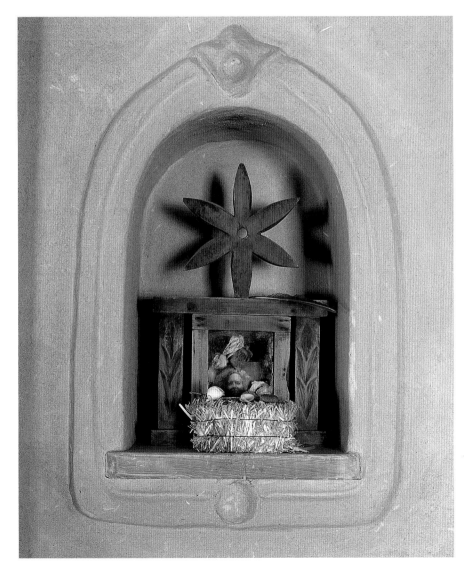

Carol Anthony's memorial altar to her sister shelters "bits and pieces of Elaine's spirit," including objects evocative of her sister's love for the New Mexico earth, such as the miniature hay bale, a Gaia vessel, and bird eggs and feathers.

Honor the Bleeding Woman: The Cup of
Guidance *is an icon I created in mixed
media. It contains the image of an inverted
benediction goblet (from which the
blood/guidance flows) and an actual benedic-
tion cup in brass that I made from found
objects. The collection of antique brass candle-
sticks comes from my ancestral homeland,
Eastern Europe.*

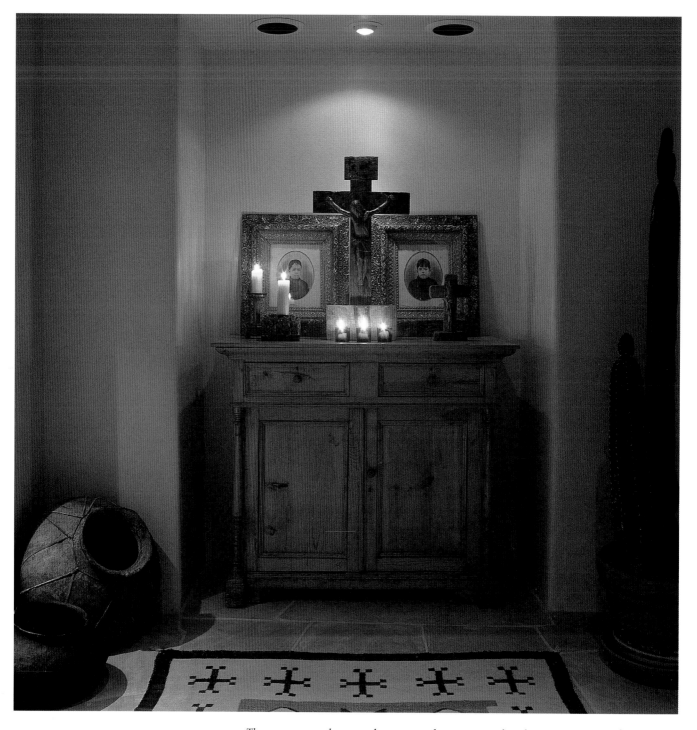

The cross is central to a stark symmetrical composition that shows reverence both for Christ and for family ancestors. Photograph by Peter Vitale.

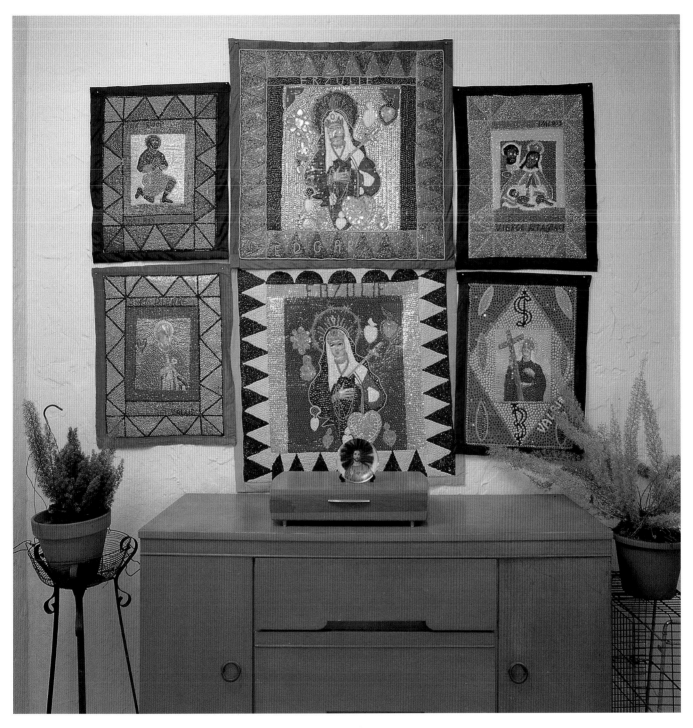

*When the African slaves brought to Haiti were forced to worship in the churches of their own-
ers, they conflated their African spirits with the imagery of Catholicism. An altar to beneficent
deities in the home of Dina and Jeffrey Knapp centers around Erzuli Freda, Virgin Mary figures.
The small Christ image with blue hair, at center, is by the artist Ruth Marten.*

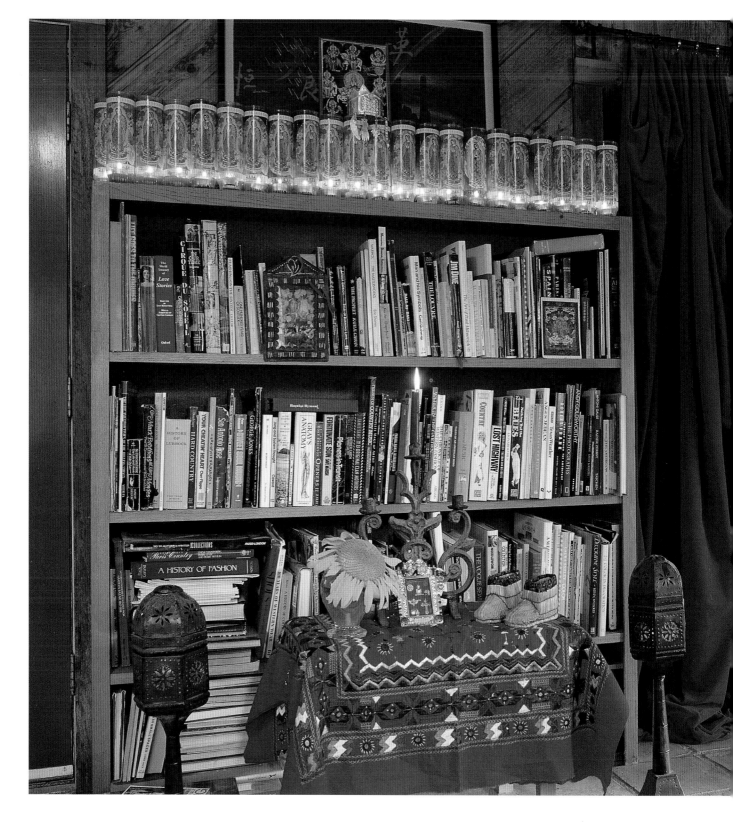

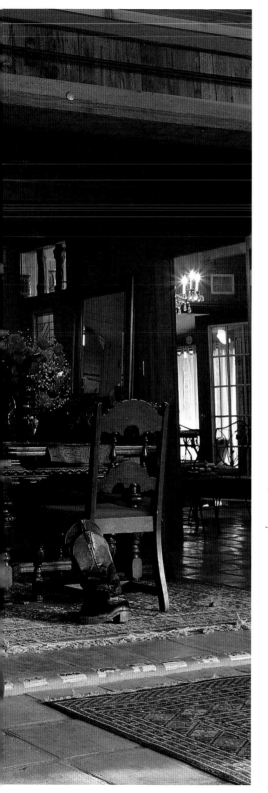

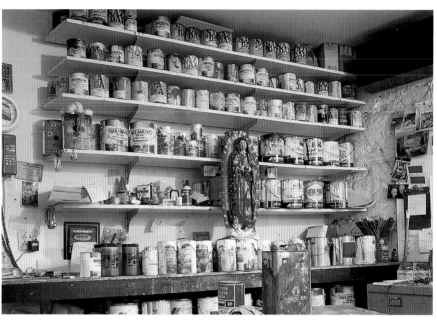

The simple placement of a plaster Madonna among artists' materials adds a spiritual grace to the working environment.

A fusion of Christian and Oriental imagery reflects Sharon Ely's Southern Baptist roots and her interest in meditation. The Tibetan baby shoes, traditional symbols of good luck, symbolize forward movement on the spiritual path. Both the sunflower, grown in her garden, and the abundance of candles express her love of radiance.

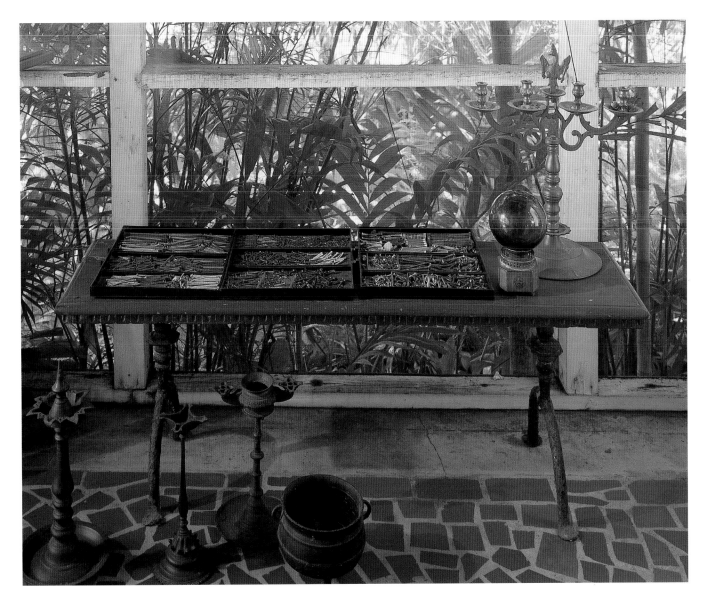

I composed an altar to the Yoruba deity Ogun, above, with a combination of traditional and interpretive symbols. The caldron below the table is a traditional receptacle for iron objects representing this god of labor. The gazing globe at right is one of my own sculptures.

The iconic image of a horse came from a discarded whiskey advertisement. Mounted in the garden, the altar is an homage to the wildness of nature.

Santería Altars

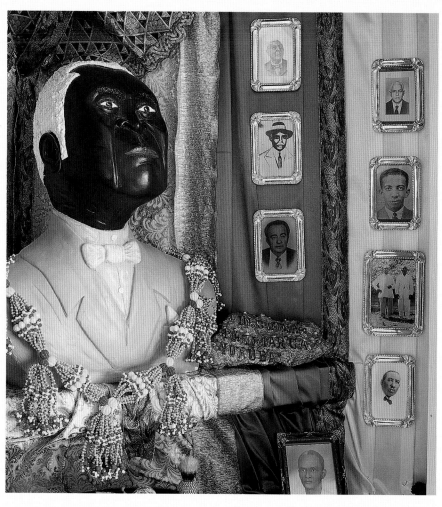

Among the most pervasively growing religions in the West is Santería, a generalized term applied to the Yoruba religion which was brought to Cuba from Africa in the 18th and 19th centuries by slaves. It came to the United States with the flood of Cuban exiles after Castro. The art, artifacts, amulets, and herbs used in its ritual practices are now available in the botanicas that flourish in many cities throughout the U.S.

Based on nature worship, the religion, also known as Ayoba, originated more than 4,000 years ago in what is now western Nigeria. It survived in the West by being cloaked in Catholic imagery. Santería teaches faith in an omnipotent deity called Oludumare, the Creator, and his children, the Orishas. It incorporates ethical and theological principles along with millennia-long traditions of herbal medicine, prayer, protective charms, chants, magic, marriage and death rites, as well as food and animal offerings and dietary taboos.

Santería altars are sacred places where, through rituals of offerings and prayer, worshipers can draw down the specific spirits they wish to reach. The altars on these pages were created by the Iya Orlorisha—or priestess—Carmen Pla.

An altar to Babalu Aye, the Santería deity who reigns over health and, indirectly, over subsistence. The beaded object at right is used in purification rituals. It is called a Ha and symbolizes the walking stick Babalu Aye used while suffering from blindness. The fruit offerings represent Babalu Aye's reign over the interior of the earth and over all biological organisms.

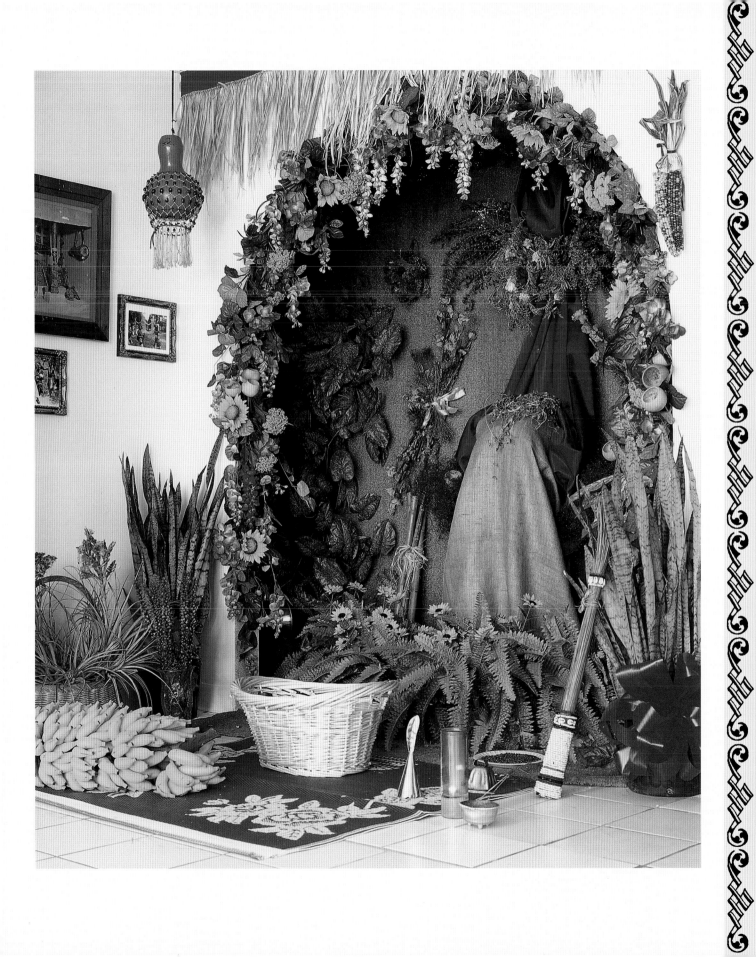

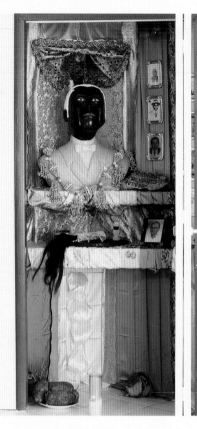 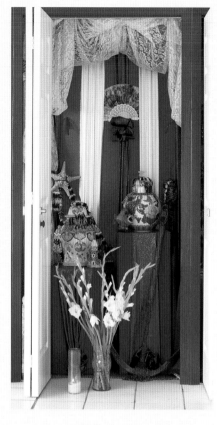 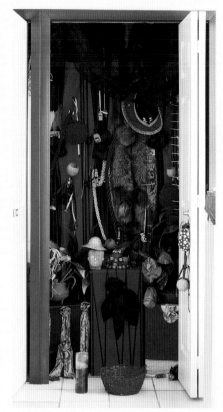

An altar to Adeshina, a slave who pioneered the worship of Ifa in Cuba during the late 19th century. The photographs are of four of his descendants, who represent the first and second generation of Ifa priests. The yams on the floor acknowledge their importance as a staple food in both Africa and Cuba.

An altar to Yemaya, the mother of the world and of marine life. Her color, blue, represents water, while white symbolizes the light over and within the ocean. Yemaya is the mother figure of the earth, who rules in conjunction with the father figure Obatala.

An altar to the Ebora orishas— the warrior and hunter deities Elegba, Ogun, and Oshosi. Elegba guides destiny and is also known as the Trickster, thus the offering of toys and sweets which evoke early childhood and curiosity. Ogun, the deity of iron, controls the force of human labor and is represented by tools and weapons. Oshosi, the hunter deity, oversees subsistence and is represented by such symbols of hunting as bows and arrows and animal traps.

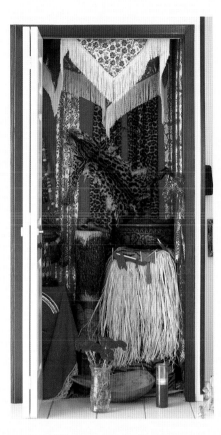

An altar to Shango, who represents the power of rule and is manifested as thunder and fire. Shango, the fourth Yoruba king, is known for his war powers, which are evoked by the leopard skin, a symbol of authority. The color combination of the beads in the altar represent each of the deities, and are part of the formal wear for priests.

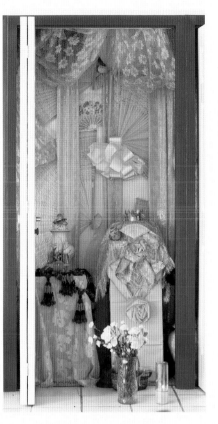

An altar to Ochun, who rules human emotions, sensuality, refinement, and prosperity. She is represented by amber or yellow and brass. The brass bell is used to summon her, and sweet offerings such as honey are used for her invocation.

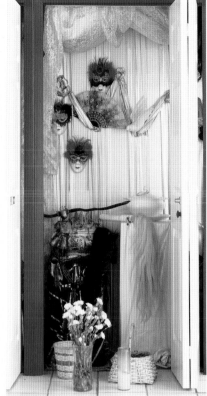

An altar to Obatala and Oya. Obatala is the supreme deity of light, purity, and wisdom to whom the creation of human beings is attributed. He is represented by white and summoned with a silver bell. Oya, the wife of the deity Shango, governs storms and tornados. Her color is brown, and the masks represent her role as transporter and witness of death. The hair represents the horse's or bull's tail used in Oya's purification rites.

ART AND ARTIFACTS

SACRED IMAGERY DEMONSTRATES THE DYNAMIC, EVEN GALVANIC POTENTIAL OF ART TO EFFECT CHANGE. SUCH OBJECTS LEAD VIGOROUS CLAMOROUS LIVES. PAINTINGS WEEP AND BLEED AND HYPNOTIZE. SCULPTURES FLY THROUGH THE AIR AND CRY OUT, ANSWERING PRAYERS AND MAKING DEMANDS. FAR FROM BEING PASSIVE, THEY SOLVE HUMAN PROBLEMS, HEAL BODILY WOUNDS AND EVEN SAVE SOULS.

Holland Cotter

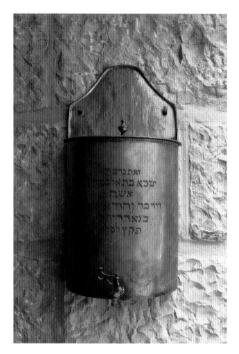

The art and artifacts associated with spiritual practice have served as compelling "decoration" ever since the first wall paintings were applied to the caves of Lascaux. The presence of meaningful imagery and objects in the home has nourished humanity's need for spiritual reinforcement and visual inspiration. Today, many forms of spiritual art are widely and avidly collected purely for their decorative appeal. Yet when displayed, they nevertheless exert distinct metaphysical power.

The display of art and artifacts introduces ideas, shapes, color, pattern, and texture to a room. But their selection and placement can make the difference between a purely decorative atmosphere and one of inspiration. The choice of image, object, or instrument is usually determined according to the dictates of a specific spiritual practice. But sometimes objects from a variety of traditions are selected in order to represent a more eclectic approach to spiritual practice.

In recent years, many once rare and precious religious artifacts have become readily available to the design markets. Ritual masks and beads, temple figures and icons are now available everywhere from art galleries to the Pottery Barn. In fact, in many houses they have replaced heirlooms as prized objects of display. Where once the family's generations-old Meissen held prominence on the mantel, today it may well be a collection of Buddhist prayer wheels. Consequently, the relationship of personal meaning to objects takes on a new dimension in rooms designed in a spiritual style.

Above: A laver used for washing the hands before entering the household on religious days is mounted on a wall outside a Jerusalem house. Photograph by Steven Brooke.

Opposite: A collection of 18th- and 19th-century silver artifacts used in Catholic worship compose an elegant tableau.

The tableau on the facing page is composed of sumptuous elements such as 19th-century silver and embroidered velvet to reflect the rich visual glory of Catholicism. The simple display of antique hadas, ritual spice boxes (page 99), on the other hand, is an understated homage to a Jewish ceremony called the Havdalah that symbolizes the passage from the sacred to the profane, from the Sabbath to the six working days. The presentation is careful yet unstudied; the details of the objects reveal themselves on contemplative inspection.

Lavish in quantity, but similarly modest in style of presentation, is the collection of antique *menorot,* or Chanukah lamps, in the house of an antiquarian (pages 100 and 101). Candle holders of various origins and ages, mostly made of brass, fill windowsills, walls, and tables. The owner displays them copiously and conspicuously "to continuously remind myself of the possibility of miracle and the blessings of light."

Even under renovation, this house gains spiritual elegance with the placement of select implements and art. In a simply improvised composition, a *kitubah,* illuminated wedding contract, signifying the consecration of the householders' marriage, celebrates with its beauty the holiness of marital union. The document is illuminated and lettered by an ordained scribe and must be witnessed by a rabbi and at least one other man. The Russian samovar, which is used during the Sabbath, enlivens an uncompleted corner of the room with its sculptural strength.

Ornate crosses are displayed as forms of reverence and for their individual beauty in homes throughout the Catholic world, especially Italy, Sicily, Portugal, South America, Mexico, and the southwestern United States. Their placement on a mantel or table can evoke the sense of a church sanctuary. A wall composition (page 103) allows for crosses of various sizes to be combined easily with each other as well as with different artifacts and framed pieces. An arrangement of crosses and artifacts massed together and hung on a wall from chair rail to ceiling, salon style, gives a room more of an Old World look than would the spotlighting of a singular piece.

A display of ceremonial jewelry and clothing (pages 104 and 105) can dramatize a room with its ornamental and ritual power. Their color and patterning, which often originate in some form of mantric tradition, engage both the eye and mind.

Jewelry may have been worn by humans before clothing, first to attract the opposite sex and, later, to symbolically protect the wearer. In ancient cultures, charms, fetishes, amulets, and talismans made of stones, bone, fur, animal teeth, shells, and feathers served as symbols of mystical, political, and even medicinal authority. The earliest amulets, likely animal bones, were worn to protect the wearer against attack from wild beasts. Eventually they were associated with the general safeguarding of life and were worn for the prevention of specific ailments or the curing of disorder.

The earliest "beads" were made from seeds, and beaded jewelry was believed to carry great powers of fertility. First worn ornamentally to attract the opposite sex, its powers extended to those of blessing and protection. Many African and African-based religions continue to use beads in various forms of worship. Those shown on page 104 are called *ilekes* and have been sanctified in a Santería ceremony and

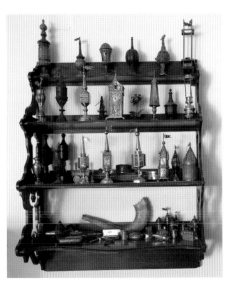

A collection of hadas or spice boxes used in the Jewish Havdalah ceremony. The custom of smelling spices continues an ancient tradition of incense burning and the burning of spices at the end of ceremonies and festival meals. Myrtle leaves produced the preferred fragrance. The earliest recorded use of a special vessel for Havdalah spices dates from a 12th-century scripture which reads, "I have a small glass of spices over which I recite the blessing." Photograph by Steven Brooke.

A rare antiquarian book shows illustrations of artifacts used during various Jewish holidays. Photograph by Steven Brooke.

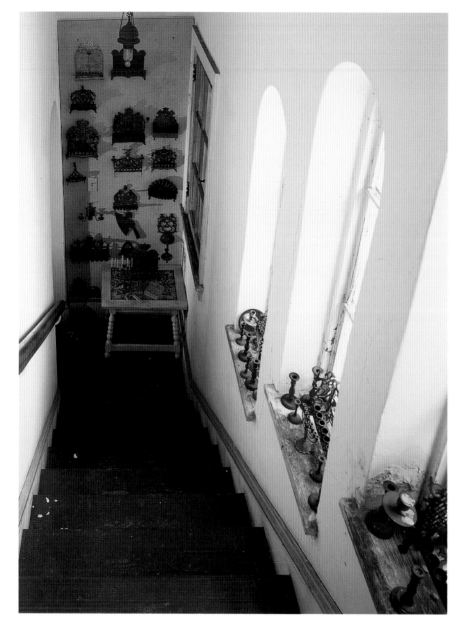

A stairwell serves to display a collection of antique brass menorot, the candelabra used at Chanukah, the Jewish celebration of light. Photograph by Steven Brooke.

bestowed upon the wearer in another separate ceremony.

Like jewelry, ritual garments are often laden with symbolism and are worn repeatedly on occasions of sanctification. An Islamic wedding cape from Turkmenistan serves as a wall decoration in Tirza Moussaieff's Jerusalem home. Turkmenistan is one of the Central Asian republics that was originally part of Bukhara. The robe, displayed in combination with the Bukharan porcelains, make her apartment a shrine to her ancestral home.

As representations of the supernatural, masks play a large role in the spiritual practice of many tribal cultures, especially those of Africa and Oceania. Protective and transformative, they provide the wearer a means for acting out the primal emotions engendered in rites of initiation and transition. Animal, bird, and plant masks denote communion with the natural world. Representations of sacred figures, often fantastical, are believed to transmogrify the qualities of the deity into the wearer.

The display of ritual masks reinforces the transformative nature of a spiritual environment, animating it with the masks' expressions of ferocity, beneficence, humor, or even terror. The New York couple who surround themselves with tribal artifacts have installed masks in every room of their apartment in acknowledgement of their protective qualities (page 106). They consider the masks mounted on a shelf over their bed to be guardians of their dreams. They also cherish their masks for their narrative richness. Each tells a story—of its culture, of its maker, and of the expectations of the wearer.

Sensitive to the metaphysical energies borne by tribal art, the couple collects textiles as well as sculptural art: the former because traditionally it is created by

women, and the latter because it is crafted by men. "We specifically seek out the two forms because they complement each other aesthetically and emotionally—a balance we find fundamental to the spiritual nature of our home." Handwoven tapestries, carpets, ikats, as well as ceremonial textiles are displayed along with ritual masks, sculptures, and implements.

The bedroom shown on page 108 is a shrine to the confluence of spiritual expression. Richard Warholic created the altar as a reverence to Buddhism and to other Eastern religions that have formed, in great measure, his personal and artistic philosophies. Below the altar an astrological scroll reveals the symbols of the zodiac. On his walls hang a collection of icons Warholic created using Russian Orthodox imagery in homage to his family's religious heritage.

The icon, an earthly image imbued with mystical influence, evolved from ancient Egyptian death masks and was adapted to Christian symbolism in the centuries following the death of Christ. According to Russian Orthodox teaching, icons are created not by the design of the artist but by direct communion with the Holy Spirit. Meditation upon an icon is a form of prayer, a means of uniting the sensory world with the celestial, an earthly process used to acquire heavenly experience, a means of delivering the viewer from the "darkness of earth to the uncreated light."

Because divine light was believed to pervade every aspect of an icon, the human figure was never portrayed in shadow, for "there are no shadows in the Kingdom of Heaven." The devout worshiper was led into a state of self-immersion: He would have difficulty taking his eyes from the image and would be drawn into a state of deep prayer.

Russian, Greek, and other Eastern Orthodox icons are widely collected today as

A kitubah or illustrated wedding contract hangs over an antique samovar which is used to heat water in a religious household on the Sabbath when the use of electricity is prohibited. Photograph by Steven Brooke.

Skeletons and other images of the dead are familiar presences in Mexican culture where death is celebrated. This table, with a skeleton carved on its underside, was made by the artist Boyd Wright, who died a month after completing it.

art objects. Many fine 19th-century icons can be purchased in galleries, antique stores, and auction houses in the hundreds-of-dollars range.

Hindu icons are coddled and cosseted by their devout. "They are pleasured with incense, the ringing of a sweet-sounding bell and fruit served in pretty dishes," writes Holland Cotter. "Gods and goddesses have the power to heal, but they also have appetites like our own." Buddhist icons are also an object meant for physical interaction. They are often filled with concealed votive objects such as miniature Buddha figures, printed prayer scrolls, and symbolic relics, and some require personal "grooming" and fitting for robes.

Like icons, scrolls made by professional diviners and healers often hold mystical power. In some cultures they are used to induce a trance, "so that a demon peering out through the patient's transfixed gaze will himself see the scroll's potent images and depart from the body in alarm." Other forms of scrolls are created to promote meditation and to instruct on prescriptions and practices of the path to enlightenment. Their power lies not only in the images the artist draws but equally in the faith the viewer brings to them.

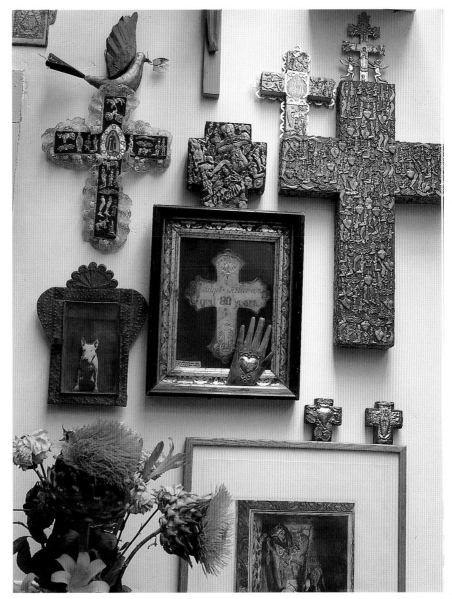

Ornately embellished wooden crosses from Mexico cover a living-room wall in the Albuquerque home of Jim Kraft and Judy Booth.

The Burmese lacquered scroll shown on the wall of a New York apartment (page 110) contains prescriptions required for ordination of a Buddhist monk. Its compelling gold leaf calligraphy, an art form in itself, represents part of the power of the "document." Even in its folded state (page 111), the beautifully bound scroll is an expression of the sacred.

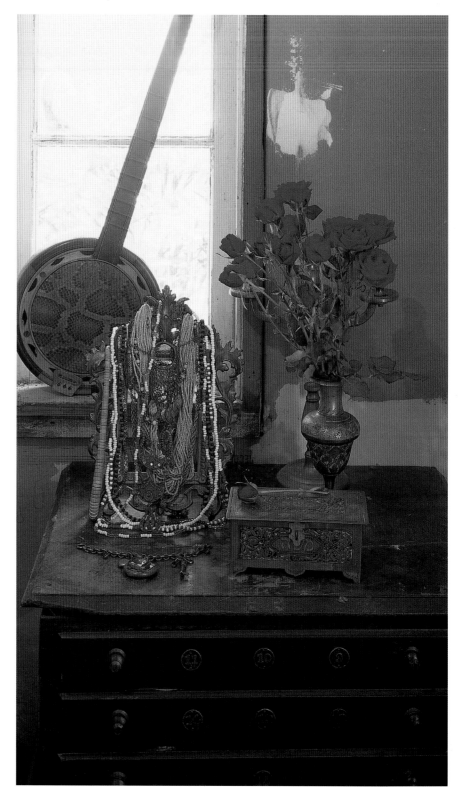

A decorative tableau with jewelry includes a talisman bracelet, foreground, and a set of ilekes, beads that have been ceremonially "activated" by the Yoruba deities known as Orishas to guide, bless, and protect the wearer. Photograph by Steven Brooke.

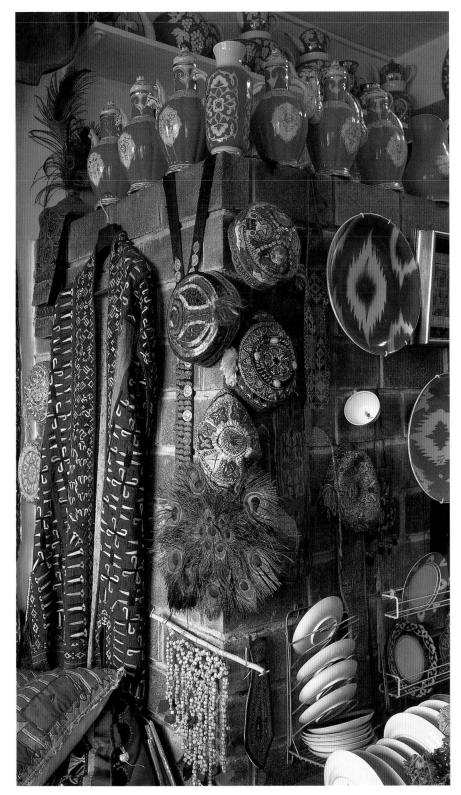

The walls of a Jerusalem apartment display a ceremonial robe and collection of Bukharan porcelains in typical vivid colorations that reflect those of the abundant fruits and other crops of that region. The plate at right shows the ikat pattern for which the region is known. Photograph by Steven Brooke.

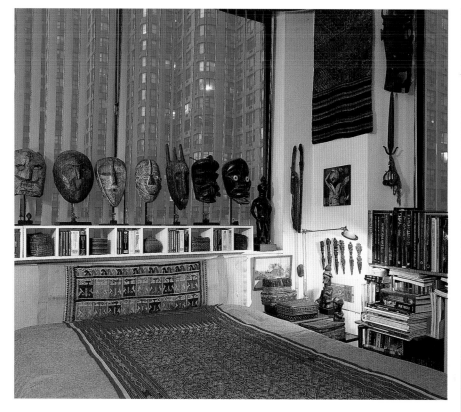

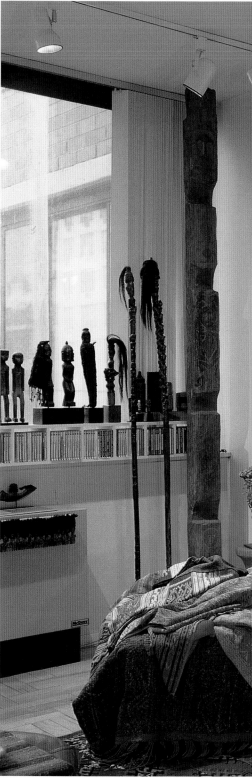

In the bedroom of a New York apartment, a collection of tribal masks includes, from left to right on shelf: an ancient mask from Nepal; "Pere," an owl mask from Zaire; a Lega mask from Zaire; a 19th-century Ibo monkey mask from Nigeria; a Bamana mask from Mali; a Bete mask from the Ivory Coast; a Dan mask from the Ivory Coast; and a Mende medicine figure of a woman from Sierra Leone. The ikat bed covering is a "Pua" from the Iban tribe of Borneo. The "Firefly" design in the weaving represents the weaver's dreams.

On the floor is a 19th-century Central Asian Maon carpet from the Yomut tribe. Along the wall, from right to left, are: a 19th-century ceremonial canoe prow from Tanimbar, Indonesia (on the speaker); a Mentawai knife; a group of eight African terra-cottas; a back carrier and a coffin lid from Borneo. On top of the stereo speaker is a large Tami Island bowl, and on a lower shelf of the bookcase are masks from Africa. On the floor, from right to left: a white Suku helmet mask from Zaire and Yombe mask from Congo; a pre-Columbian stone jaguar "Metate" from Costa Rica, circa A.D. 1000. Between the ladders is a Tchokwu mask from Angola. To the left sit two 19th-century Batak sorcerers' staffs. On the CD shelf are, from right to left, containers from various Southeast Asian tribes; a finial from a 19th-century Batak sorcerer's staff; a Batak magical charm; a rare pair of Batak gods; a pair of Ataoro figures from Indonesia.

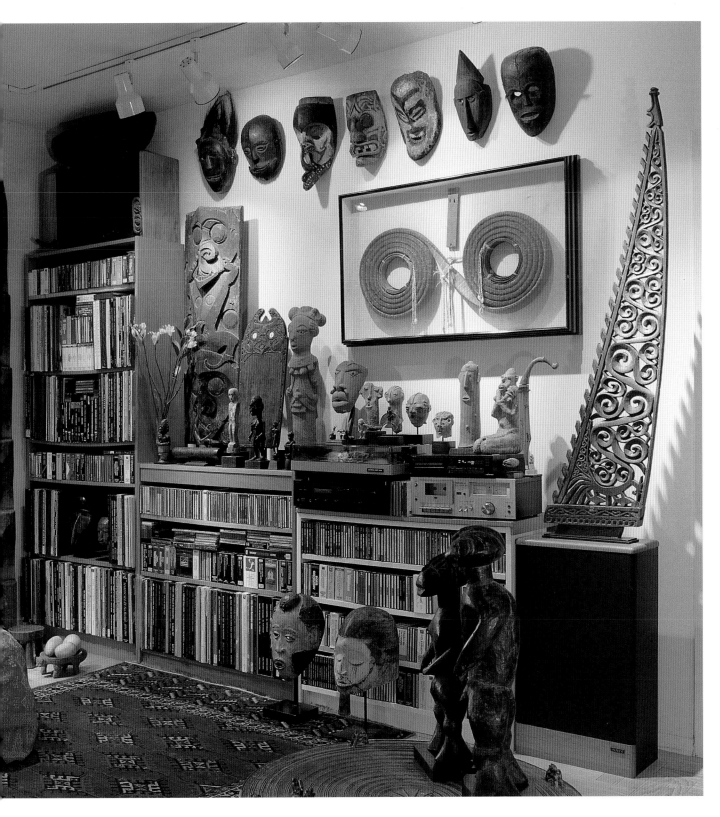

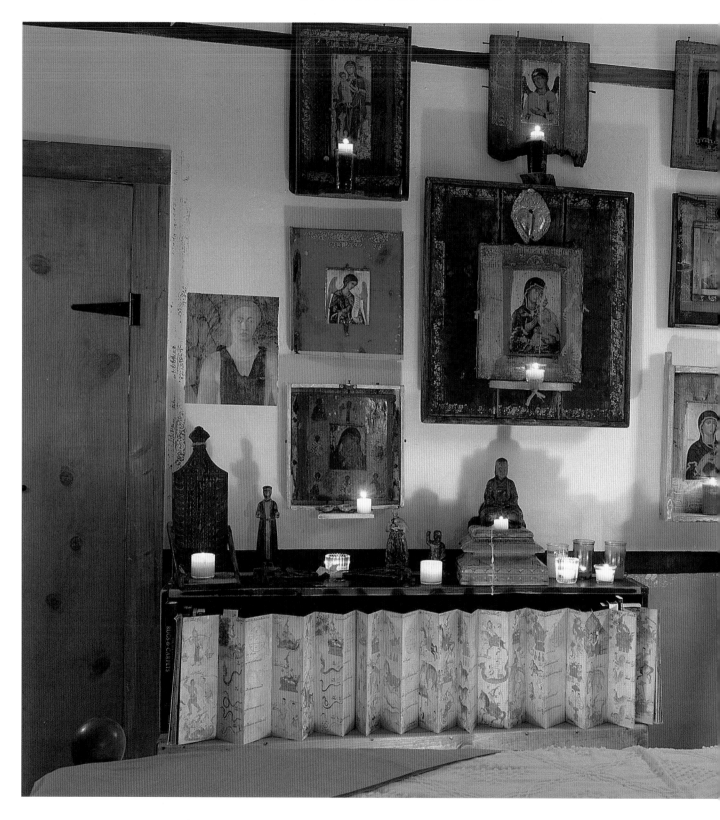

Russian iconic imagery mounted on pieces of discarded wood by Richard Warholic fill the walls of his bedroom. The altar below includes a Buddha figure and folded-out astrological zodiac scroll from Thailand.

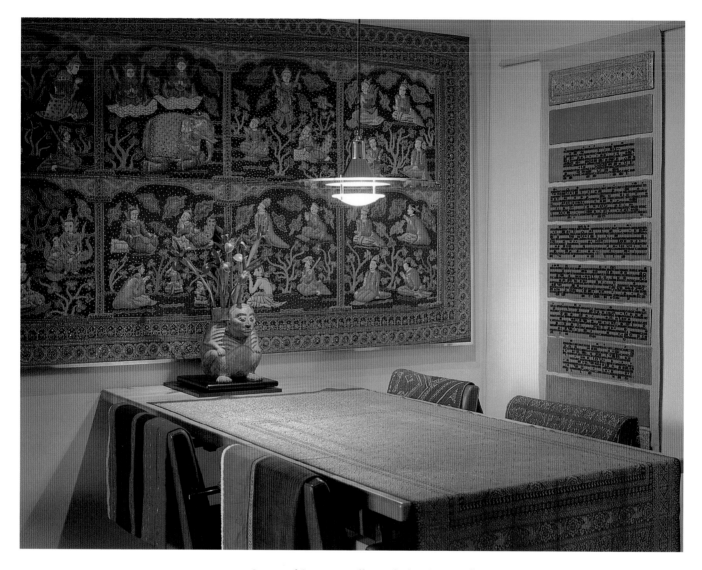

Lacquered Burmese scrolls on which ordinances for Buddhist monks are calligraphed are
shown opened out on the wall of a New York apartment, above, and folded up and bound on
the dining-room table of Albuquerque architect Robert Strell. Opposite, a repoussé lantern
and flame, mounted on the gold-leafed wall behind the table, represent sacred fire.

ACKNOWLEDGEMENTS

*Much gratitude to Don Thomas, Jorge Cao, Robert Strell,
Pamela Blum, Peter Vitale, and Harry Greiner, whose gracious hospitality
made the shooting of this book possible.*

*Our reverence to Maharaji, who brought so many
of us together in Knowledge.*